IMAGES
of America

HISTORIC RUGBY

NEW RUGBY

'Tis a scheme that is truly gigantic
Tom Hughes has just started, for he
Is taking across the Atlantic
To settle in far Tennessee

A new colony, peopled by dozens;
Many settlers, the young and the old,
With their wives, and their sisters, and cousins
Are all gathered into the fold.

They're to sow on the fair mountain ranges,
They're to reap and to trade in the mart;
And through all Fortune's troublesome changes
They're still to be English at heart.

Quoth the wily American, "Thank 'ee,
Though now of Old England you're types;
In a very few years you'll be Yankee
And swear by the Stars and the Stripes."

This poem about Thomas Hughes's founding of Rugby in far-off Tennessee appeared in an 1880 issue of the English humor magazine *Punch*.

IMAGES
of America

HISTORIC RUGBY

Barbara Stagg

ARCADIA
PUBLISHING

Published by Arcadia Publishing
Charleston SC, Chicago IL, Portsmouth NH, San Francisco CA

Printed in the United States of America

Library of Congress Catalog Card Number: 2007922538

For all general information contact Arcadia Publishing at:
Telephone 843-853-2070
Fax 843-853-0044
E-mail sales@arcadiapublishing.com
For customer service and orders:
Toll-Free 1-888-313-2665

Visit us on the Internet at www.arcadiapublishing.com

To John, Rugby's master restorer for 30 years—with more to come.

CONTENTS

ACKNOWLEDGMENTS

This book would not have been possible without the actions and foresight of many people no longer with us. I am deeply grateful to young Emily Hughes, who taught herself photography in the 1880s and took and developed many pictures of early Rugby; to Will and Sarah Walton, who understood that the hundreds of records and photographs of Rugby's early life would someday be historically important and guarded them until their deaths in the 1950s; to their nephew James Keen, who copied and preserved every early photograph and took many more himself that document Rugby life from the 1930s to the 1970s; to Oscar and Irving Martin, who bought and preserved much of Rugby and whom the Waltons entrusted with early Rugby material and stories; to Dr. John DeBruyn, a dedicated Hughes family scholar who turned up many Rugby photographs, drawings, and family letters on research trips to England; to Gerard Hughes, who shared a treasure trove of family letters and pictures with me; and to my brother, Brian, who understood that all of Rugby and its records must be preserved and shared and committed 12 years of his young life to that effort.

I also want to thank the many descendants of early Rugby colonists, who over 40 years have shared their family images and materials with Historic Rugby.

Another Walton descendant, George Zepp, has worked to help document Rugby photographs and Rugby history for many years. I especially thank him for his proofing and editing help on this book.

Special thanks are due Historic Rugby staff members who supported my virtual absence from the office for many weeks while I was organizing, scanning, researching, and writing this book.

Unless otherwise credited, all images in this volume are from the Rugby Archives housed at Historic Rugby.

Author proceeds from the book's sales will benefit Historic Rugby as work continues to ensure Rugby's preservation for generations to come. As founder Thomas Hughes hoped, Rugby continues, not as a monument to failure, but as living proof of the power of a dream.

—Barbara Stagg

INTRODUCTION

From the 1840s to 1900, visionary leaders established many communities in America based on utopian goals. Why then, when most no longer exist or have been changed by modern development, has rural Rugby, Tennessee, not only survived with its heritage intact, but also begun to thrive again? Why was Rugby, for a time, an outpost of British culture in the near wilderness of the Cumberland Plateau? How did a 7,000-volume free public library come to be established there at a time when towns many times Rugby's size had none?

While the images and words in this book cannot answer these and other questions in detail, they provide the first pictorial window on life in Rugby from its 1880 founding to the present.

Like many towns and communities, Rugby owes its location to a railroad. In 1878, land speculators began staking claims to thousands of acres on the northern Cumberland Plateau along the new Cincinnati Southern Railway line between Cincinnati and Chattanooga. Among them was industrialist and idealist Franklin W. Smith. His Boston-based Board of Aid to Land Ownership planned to relocate unemployed factory workers from the Northeast to the fresh air and forests of Tennessee's Cumberland Plateau, where they could engage in agriculture. But as the industrial depression eased, Smith looked for another investor.

Enter famous British author, social reformer, and statesman Thomas Hughes. Known and beloved worldwide as the author of the semi-autobiographical young people's classic *Tom Brown's Schooldays*, Hughes also achieved prominence as a strong proponent of Christian socialism, of the cooperative movement, and of trade unionism in Britain, and as champion of the Union cause during America's Civil War.

While on a speaking tour in the early 1870s, Hughes was fascinated by what he saw in America. Especially intriguing to him were the possibilities that its vast, undeveloped land might hold for citizens of his own increasingly crowded country. As he toured the Northeast, speaking primarily on the need to "heal the breach" between the North and the South and America and England after the war, he became convinced that "emigration to America, under the right circumstances," was the best course for many of his countrymen.

Long a champion of Britain's working classes, Hughes was also concerned about the plight of younger sons of Britain's upper-class families. By tradition, they did not inherit but were nevertheless expected to "live like gentlemen rather than engage in a trade or profession that was beneath them."

As the idea for a prototype colony in America peopled with British emigrants grew in Hughes's mind, he saw an opportunity for "these two great nations, sharing the same heritage as well as the same language, to work together," forging stronger ties. When Rugby officially opened in 1880, Hughes intended it to be a class-free, agrarian community based on cooperative enterprise, cultural opportunity, religious freedom, and strict temperance. "Our settlement is open," he declared, "to all who like our principles and our ways."

During its first decade, hundreds of people emigrated from the British Isles to Rugby, and hundreds more came from other parts of America. Some stayed only briefly, some for years, and some for life. More than 60 cottages, villas, and commercial and institutional buildings of

distinctive rural Victorian styles were constructed during Rugby's first decade. It was briefly the largest town on the northern plateau. Periodicals and newspapers in both England and America followed the ups and downs of Hughes's "distant Eden."

Farming was often not pursued as avidly as other community building efforts. Colonists organized the Thomas Hughes Free Public Library, Rugby Public Purposes Association, the Rugby Social Club, the Rugby Drama Society, Ladies Church Working Society, Rugby Horticultural and Agricultural Society, and the Rugby Masonic Lodge. Christ Church Episcopal, still holding services today, was dedicated on the colony's opening day.

Around 300 people lived in Rugby at its mid-1880s heyday. Most of the gentry, farming, and working-class residents were of English, Scots-Irish, or Welsh descent. There were a few Germans and African Americans. By 1884, Rugby seemed to be thriving and achieving Hughes's hope of a "class free, cultured society willing to work with their hands."

But Rugby never sustained most of Hughes's idealistic goals for many reasons: poor communication with London-based management; soil that needed exhaustive clearing; an unusually severe first winter and drought-stricken summer followed by a typhoid epidemic; unsuitability of many of the colonists to manual labor; and perhaps most important, failure of the Cincinnati Southern Railway to build a spur line to Rugby as promised.

While immigration to Rugby slowly ceased, it was never a ghost town. By 1900, some 125 people still lived in the Rugby area, though the mix was more Appalachian than British. Fortunately for future generations, some were determined to preserve Rugby and its heritage.

From the 1920s through the 1950s, children of original colonists and others lovingly cared for Rugby's public buildings, river gorge trails, and cemetery, even as private residences were often lost to neglect or fire. Extensive media attention was paid to the need to restore and preserve Rugby.

Then, in the mid-1960s, a 16-year-old boy from nearby Deer Lodge resolved to begin what others had dreamed of—the permanent restoration and preservation of the entire village and its history. With help from area residents and people across Tennessee, Brian Stagg formed the Rugby Restoration Association in 1966. In 1972, Rugby was listed on the National Register of Historic Places.

Today 12 buildings have been restored or historically reconstructed by the renamed Historic Rugby. Private owners have restored their historic homes. A 750-acre state natural area on the south and the Big South Fork National River and Recreation Area on the north help protect Rugby from the uncontrolled development now occurring throughout the region.

Some 85 residents live in or have weekend homes in Rugby. Twenty of the original Victorian buildings still stand, including the schoolhouse; the Thomas Hughes Library, with its original 7,000-volume collection intact; Kingstone Lisle, the founder's home, with furnishings made or brought by early colonists; Newbury House and Pioneer Cottage, again used for lodging; and Uffington House, where Thomas Hughes's elderly mother and young niece once lived. The community is growing again as people build historically compatible houses in the new Beacon Hill residential development sponsored by Historic Rugby that was part of the 1880 town plan. To date, incompatible development has been prevented.

Thousands of people visit Historic Rugby annually for guided tours, workshops, special events, and overnight lodging in restored historic buildings. The reconstructed Rugby Commissary features area arts and crafts and other wares. Several privately owned shops are opening.

Hundreds of descendants of Rugby's early colonists live throughout America and other countries. Many are in touch with Historic Rugby and have furnished historic materials vitally important to the continuing effort to preserve Rugby's story. But many more are out there, perhaps in possession of important historic records and unaware of Rugby's renaissance. The publication of this book may help establish contact with some of them.

Nonprofit Historic Rugby and the Rugby community continue to strive to achieve something rare in America today—authentic preservation of an entire historic village and its setting. To learn more about Historic Rugby as its second century unfolds, visit in person or online at www.historicrugby.org.

One

THE DREAM DEVELOPS

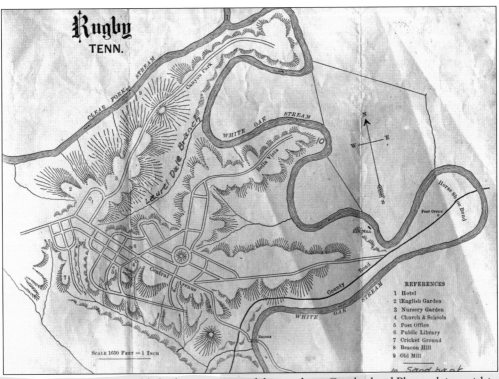

Rugby, Tennessee, was established on a portion of the northern Cumberland Plateau lying within the boundaries of the Clear Fork and White Oak Rivers. The proposed town site, 250–300 feet above these bluff-lined rivers, was intersected by numerous ravines and covered by a forest of oak, hickory, poplar, chestnut, white pine, hemlock, and walnut. Rufus Cook, a civil engineer from Boston, was commissioned in early 1879 to design the Rugby town plan. He took full advantage of the site's natural and scenic character, placing roads along ridges and in curves radiating outward from the commercial center and public parks in scenic locations. He designated commercial and institutional areas, cricket grounds (which were actually used for lawn tennis), and public pathways that provided expansive views to the Cumberland Mountains. This map is a simplified version of Cook's much more detailed town plan.

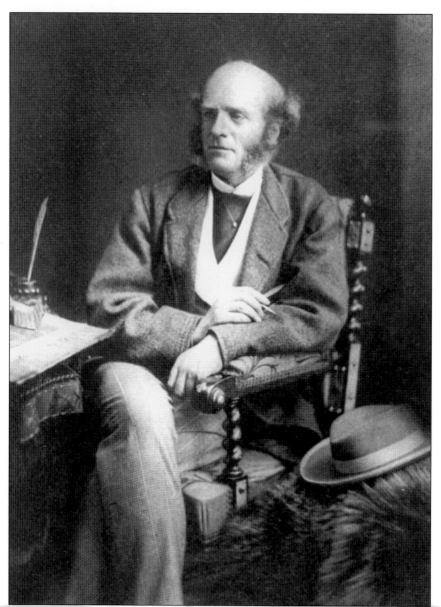

Rugby's British founder, Thomas Hughes (1822–1896), was born in the village of Uffington in Berkshire. He spent idyllic early years there wandering the downs and playing games with children of all classes, as his country squire father encouraged. After attending Rugby School and Oriel College, Oxford, he became a barrister (lawyer) in 1848. Hughes became unexpectedly world famous as the author of the best-selling novel *Tom Brown's Schooldays*. He would have preferred to be known today, however, for his life of social reform efforts. Always a champion of the working class and otherwise disenfranchised classes, Hughes was instrumental in establishing the first English trade unions and working men's cooperatives. He was a cofounder of the London Working Men's College, still holding classes today. He served two terms as a liberal member of Parliament. Royalties from the *Tom Brown* book helped finance his Rugby colonization effort. In later years, due to financial losses he suffered because of Rugby, he became a county judge at a time when he had planned to retire. Hughes's deep religious faith was the foundation of his life of service.

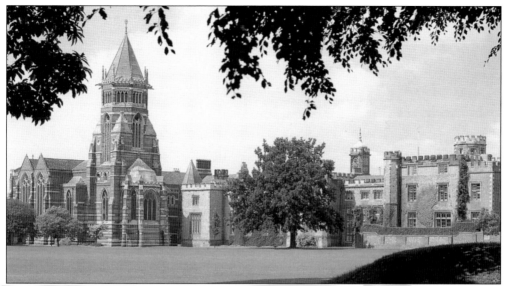

Rugby was one of the oldest and most respected of England's private schools (which the English called "public"). Thomas Hughes attended from 1833 to 1842. His experiences there under the influence of British school reformer Thomas Arnold, the headmaster, profoundly affected Hughes. The best-selling novel he later wrote was heavily autobiographical, based both on his and his brother George's experiences at Rugby.

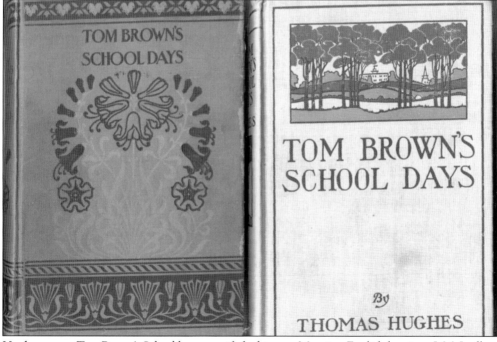

Hughes wrote *Tom Brown's Schooldays* as a gift for his son, Maurice. English barrister J. M. Ludlow read it and insisted it should be published. The London firm Macmillan published the first edition in 1857. Many more followed, securing the future of the firm. More than 170 editions, including many translations, have now been printed, and the book remains in publication. *Tom Brown's Schooldays* has been made into four movies, a London stage play, and a *Masterpiece Theatre* television series.

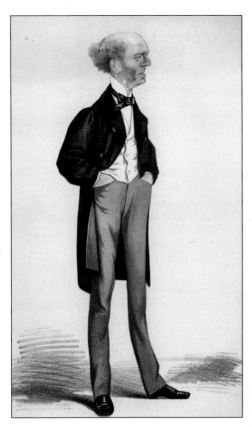

From 1869 to 1914, the English weekly magazine *Vanity Fair* ran a series of caricatures of prominent British figures. This one of Thomas Hughes ran in 1872, while Hughes was serving in Parliament. The artist was Sir Leslie Ward, who signed his work simply as "Spy."

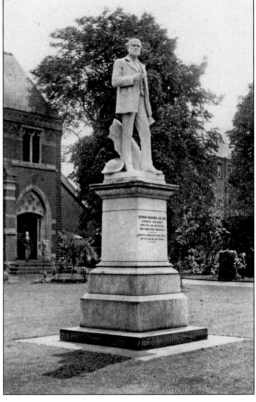

This statue of Thomas Hughes was erected on the Rugby School grounds several years after his 1896 death. Along with poet Matthew Arnold, Hughes was considered one of the most famous of the "old boys" who graduated from Rugby. The inscription includes the phrases, "Stand fast in the faith. . . . Quit you like men."

The new Cincinnati Southern Railway line to Chattanooga opened transportation to the northern Cumberland Plateau. This map, published in a bulletin promoting colonization, shows the route of the new railway and notes that it passes through the area where Rugby was being established.

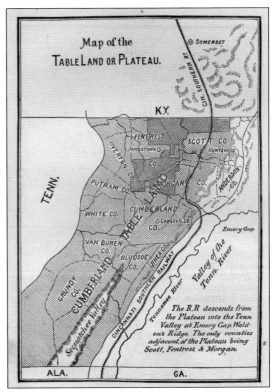

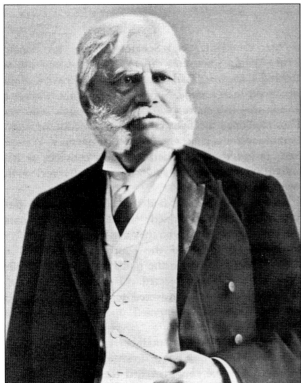

Industrialist and idealist Franklin W. Smith was one of the first to note the Cumberland Plateau's settlement possibilities. His Boston-based Board of Aid to Land Ownership had planned to relocate unemployed factory workers from the Northeast to the plateau during an industrial depression. When the depression abated, Smith found an enthusiastic partner in Thomas Hughes.

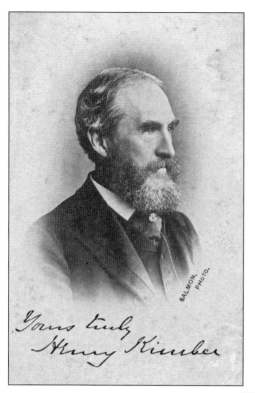

Sir Henry Kimber was a member of Parliament and wealthy railroad magnate in England. He had been involved in other English colonizing efforts in such locations as New Zealand. Kimber knew and respected Thomas Hughes and quickly agreed to become part of the London-based Board of Aid in partnership with the Boston group. As the wealthiest member of the London board, Kimber probably provided more funds for Rugby development than anyone else.

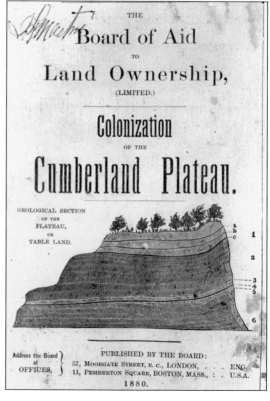

The cover of this 1880 bulletin to promote colonization of the Cumberland Plateau in and around Rugby shows the early partnership of the Boston and London Boards of Aid to Land Ownership in the addresses at the bottom. By 1881, the London group, headed by Hughes, had bought all interests from the Boston group, though correspondence indicates Smith remained somewhat involved.

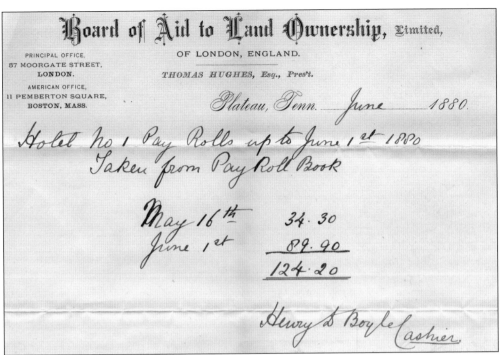

Board of Aid to Land Ownership, Limited,

OF LONDON, ENGLAND.

PRINCIPAL OFFICE,
57 MOORGATE STREET,
LONDON.

THOMAS HUGHES, Esq., Pres't.

AMERICAN OFFICE,
11 PEMBERTON SQUARE,
BOSTON, MASS.

Plateau, Tenn. June 1880.

Hotel No 1 Pay Rolls up to June 1st 1880
Taken from Pay Roll Book

May 16th 34.30
June 1st 89.90
 124.20

Henry D Boyle Cashier.

Note that the location name on this Board of Aid payroll statement in June 1880 is Plateau. The name Rugby was not decided upon until just before the official opening day in October. By Hughes's account in his book *Rugby, Tennessee*, the name "was adopted unanimously on our return in twilight from the tennis-ground, and application at once made to the State authorities for registration of the name, and establishment of a post-office."

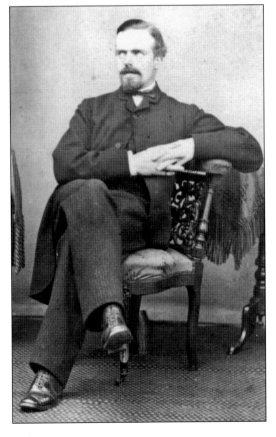

After his sherry importing business failed, Thomas Hughes's brother, Hastings, left London in early 1880 for the Cumberland Plateau to aid the colonization effort. He was not convinced that the Rugby experiment was well advised but was eager to help. Correspondence and accounts in early editions of the *Rugbeian* newspaper make it plain that Hastings represented his brother well during Rugby's first year and beyond.

15

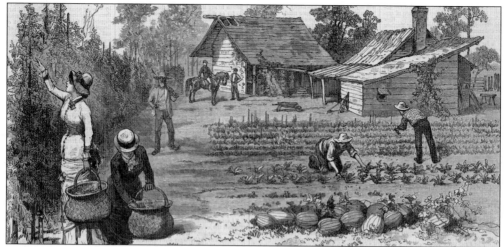

The American publication *Harper's Weekly* sent artist Frank H. Taylor to Rugby in 1880 to produce sketches of the new colony. Six of them appeared in the October issue. The scene in this sketch was called "The Gardens" for the role it played in demonstrating Cumberland Plateau gardening methods to the incoming colonists. The Delaney Tompkins log home and outbuildings shown predated Rugby by at least two decades.

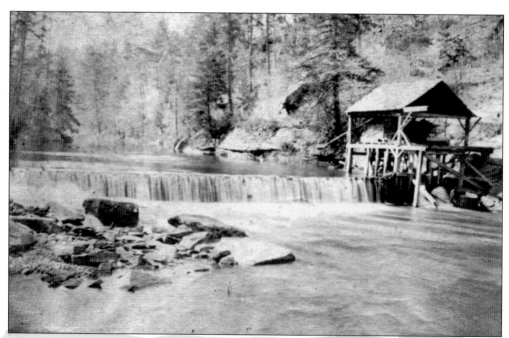

John Buck and family already lived north of the Clear Fork River when Rugby was founded and had built this mill some years earlier. It was a favorite destination for the colonists. "The Old Mill at Rugby," a poem written by visitor Claiborne Addison Young, romanticizes it: "A realized Arcadian dream is this old mill on Clear Fork stream. Wind on, oh stream, grind on, oh mill, where men pay toll from sheer good will."

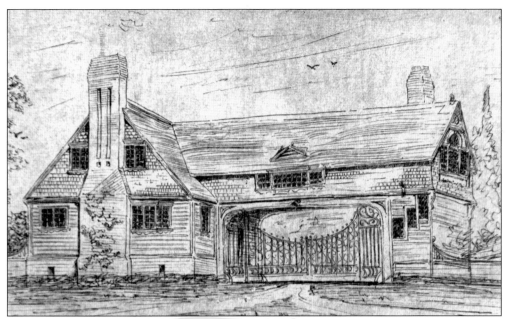

This preliminary sketch of a proposed Rugby gate lodge survives in the Rugby Papers Collection at Tennessee's State Library and Archives. It was drawn by Charles Coolidge Haight, a prominent New York architect who designed several buildings for Columbia and Yale Universities. Lettering on the drawing reads: "Proposed Gate Lodge for Rugby Tenn—General View from Road." It was never actually built.

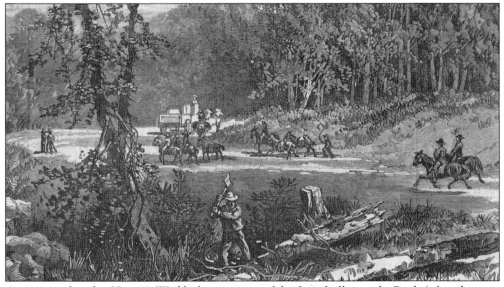

As portrayed in this *Harper's Weekly* drawing, one of the first challenges for Rugby's founders was constructing and maintaining a 6-mile road to the Cincinnati Southern Railway line in newly laid-out Sedgemoor (later called Rugby Road and today Elgin). Monies from an entrance tollgate (shown on the cover) helped maintain the road. Published tolls were "wagon and cart with one animal, 15¢; each horse or mule ridden or driven, 5¢."

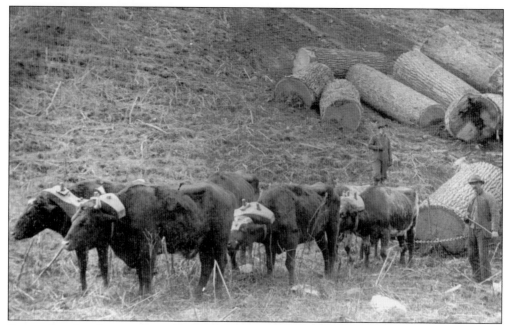

Except for a few farmsteads established by earlier Scots-Irish settlers, much of the Rugby town site and surrounding lands were covered with old-growth timber that had to be removed before farming could begin. These unidentified men skidding huge logs with a six-oxen team were probably hired to help with clearing.

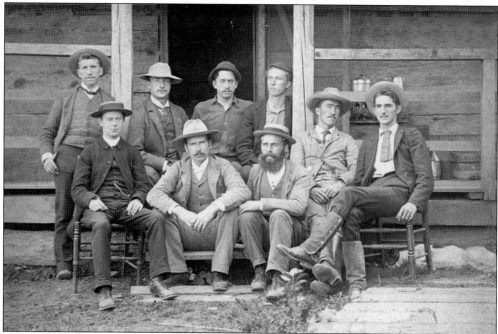

These nine young men on the steps of the John and Delaney Tompkins log cabin are probably typical of the many younger sons who came to Rugby during its first several years. Many of these younger sons proved poorly prepared for a life based on agriculture, but some did take hold and make important contributions to early Rugby's growth.

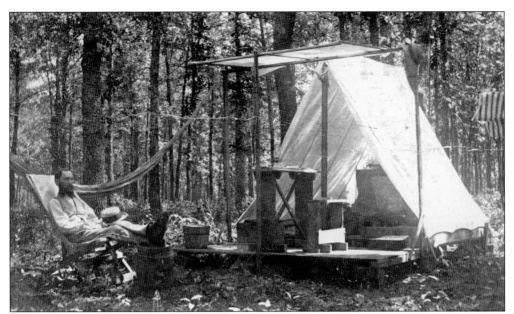

If there was no room in the so-called Barracks or the Asylum set up for those who needed lodging, some of the early colonists made do with tent living. This unidentified gentleman seems quite comfortable in his temporary quarters.

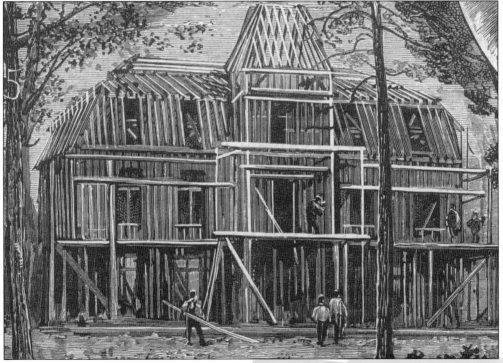

One of Frank Taylor's *Harper's* drawings detailed the Tabard Inn under construction in early 1880. The Board of Aid financed the elaborate hotel and named it for London's ancient Tabard Inn, made famous in Chaucer's *Canterbury Tales*. A baluster from the demolished London hotel was given to the board by an early visitor and displayed in a glass case over the entry hall fireplace.

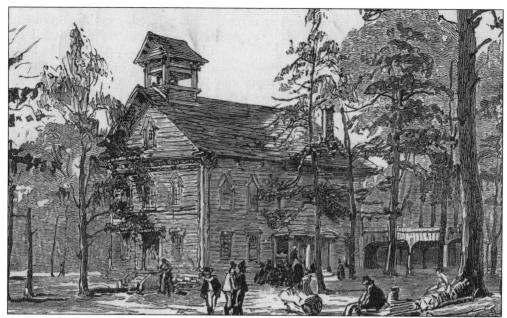

Another *Harper's* drawing shows the handsome three-story structure built by the board in 1880–1881 to serve as a multi-denominational church and school. Early newspapers are full of accounts of the activities that took place here. In his opening-day speech, Hughes expressed the hope that "the experiment will be tried whether the members of different Christian denominations cannot agree well enough to use one building for their several acts of worship."

Robert Walton, who had emigrated from County Cork, Ireland, a decade earlier, came to Rugby before its official dedication in 1880. He was a civil engineer and surveyor in Cincinnati when attracted to Rugby's prospects. After Walton's hard work of laying out roads, lots, and tracts on the town site, Hughes appointed him official manager of the colony in November 1881. He held the post until his death in 1907.

Surveyors, led by Robert Walton, here standing at the door of the Board of Aid land office, worked hard to lay out all streets, roads, park areas, and walking trails. Hughes quickly found that titles to some of the tracts the board had purchased were disputed, resulting in more surveying and court cases, all of which the board won. To the left of Walton is Hastings Hughes; Charles Wilson is leaning against the porch post at right. Others are unidentified.

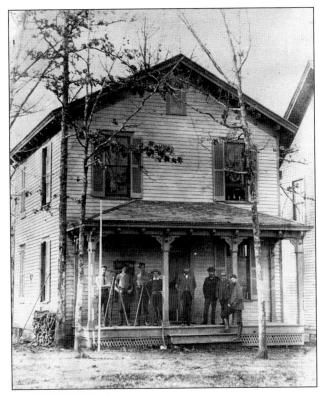

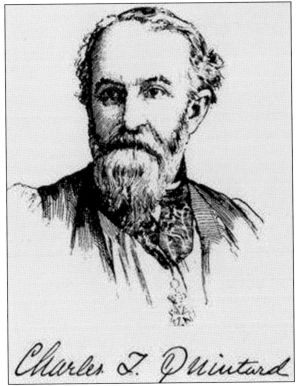

Charles T. Quintard

Bishop Charles Todd Quintard was head of the Tennessee Episcopal Diocese when Rugby was founded. He traveled from Chattanooga with many of that city's dignitaries to take part in the grand-opening ceremony. Afterward the bishop organized a vestry and two lay readers from among the colonists and officially established Christ Church Episcopal.

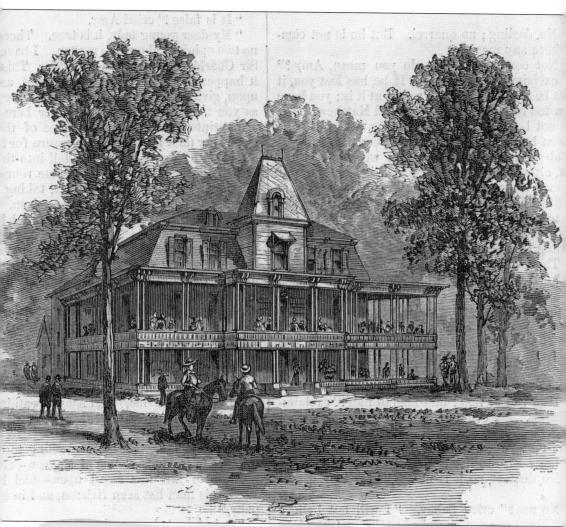

Boston architect George A. Fuller designed and supervised construction of the Tabard Inn. His firm later designed many of Chicago's largest buildings and several World's Fair structures. This *Harper's* drawing shows the Tabard as it looked on October 5, 1880, the opening day of the colony, which took place on the hotel veranda. Dignitaries from England, the Northeast, and Tennessee cities attended. The hotel faced the Clear Fork River gorge.

Two

A New Center of Human Life

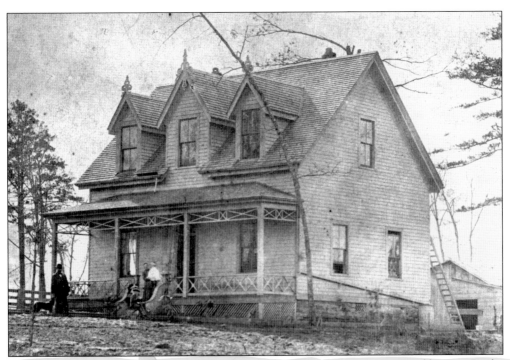

Robert Walton drew up the plans, and Winkley and Rigney Builders constructed his new Rugby home in 1880–1881. He named it Walton Court for his ancestral Ireland home. Walton stands on the lawn in this early picture; his wife, Elizabeth Taylor Walton, holds their daughter, Esther. Sons Will and John Kimber are just visible below. Three more children were born to the Waltons by 1890. Walton's contributions and dedication to the development of Rugby cannot be overstated.

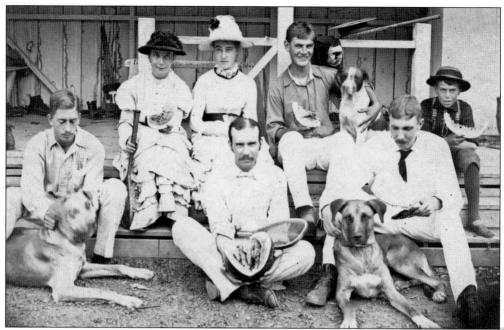

While Rugby land titles were being sorted out in 1880–1881, often in court, early colonists pitched in to clear the site for a lawn-tennis ground in the forest and officially chartered the Rugby Lawn Tennis Association, one of the earliest in America. This group enjoys some watermelon at the small clubhouse. Seated top right is George Shaw Page, an early young English emigrant who eventually moved to Canada. The others are unidentified.

The Board of Aid had this large stable built to serve the Tabard Inn and the colony. Newspaper accounts show several different colonists running the facility, where riding horses or buggies could be hired. This was the home of the hack line, which ran the six miles down to the railroad at Sedgemoor (now Elgin).

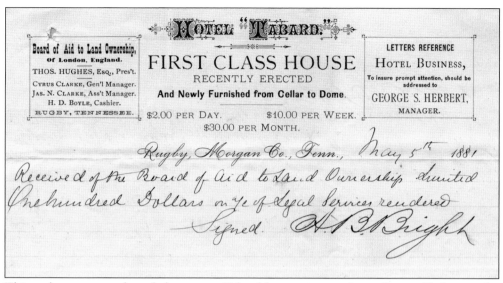

This early payment acknowledgment on Tabard Inn stationery shows George Herbert as the manager and lodging rates that seem incredibly low by today's prices.

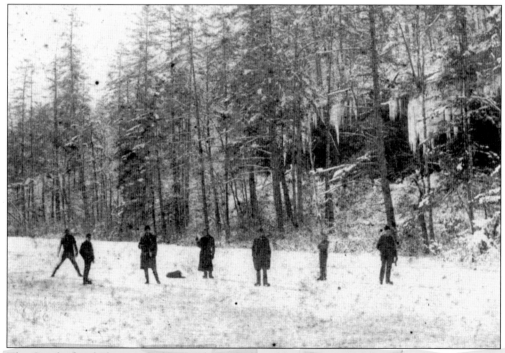

The Cumberland Plateau was known for its fairly mild winters, but to the new colonists' dismay, their first winter in 1880–1881 was the worst in a quarter century. The Clear Fork River froze solid from bank to bank. Here a group of colonists, probably mostly young Englishmen, take the opportunity to go ice-skating, an activity that was repeated on the first New Year's Eve.

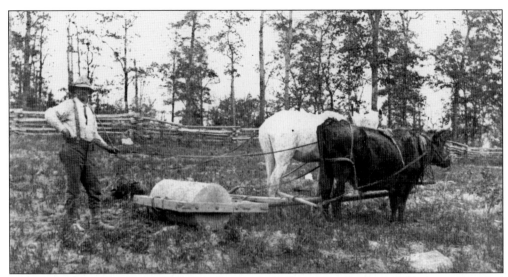

In spite of the harsh winter, many more colonists made their way to Rugby in 1881. An unidentified settler poses here with his unusual team of a steer and a horse yoked together. Farming the wooded lands involved exhaustive timbering and stump removal before ground could be prepared and crops planted.

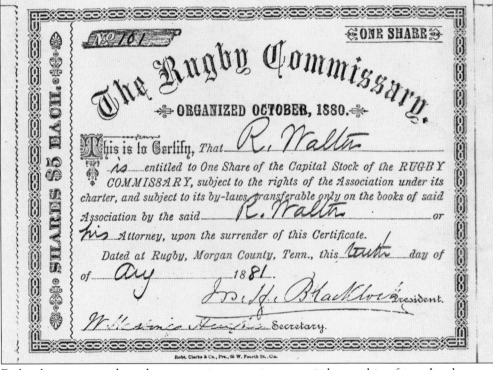

Early advertisements show the cooperative commissary carried everything from plowshares to garters for the new colonists. This copy of the share certificates sold shows the price of $5. The first issue of the *Rugbeian* newspaper in January 1881 reported that "the newly organized Commissary has been doing business since the 23rd of last month. The plan is to balance at the end of each quarter and divide the net profits among the members."

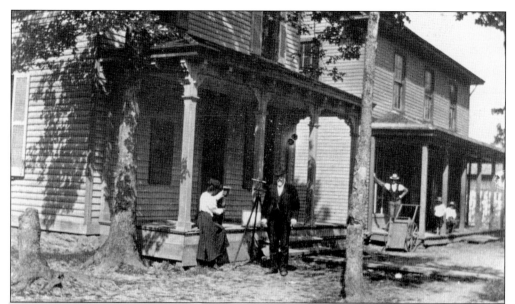

The imposing two-story Commissary, at right next to the Board of Aid office, was completed in October 1881 and was run for some years by Nathan Tucker from New England. Early newspaper advertisements offered hardware, implements, dry goods, groceries, fancy goods, seeds, and so forth "at the lowest market rates." Thomas Hughes personally provided funds to build it after many complaints from the colonists that the first small log commissary was inadequate for the growing town.

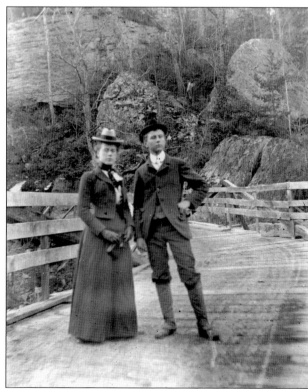

This unidentified young couple is perhaps beginning a new life in Rugby. Their style of dress indicates the early 1880s. They stand on a recently completed bridge, probably over the Clear Fork River below the town site.

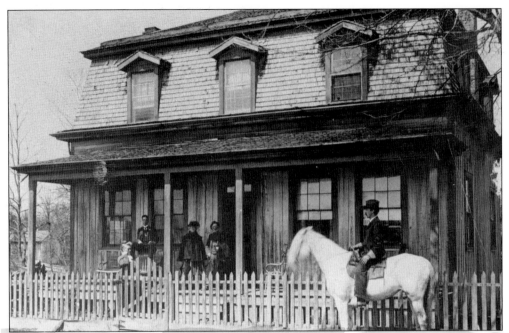

Bostonian Otis Brown completed construction of the Brown House in mid-1880, before the Tabard Inn was ready for guests. Later it was renamed Newbury House and run by James Milmow, Louise Dyer, and C. A. Clark before being purchased by the Nelson Kellogg family in the late 1880s. Ida Mae Kellogg is leaning on the gatepost chatting with guests on the veranda and a visitor on horseback. Newbury remained open to lodgers into the 1920s and possibly longer.

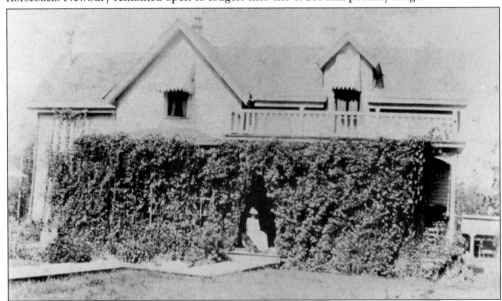

Nathan Tucker built the Lindens in 1881 after living with his wife, Emma, in the Tompkins log cabin. Emma Tucker, shown on the front veranda, raised flowers for the church altar in the glassed-front gable room, here obscured by shade-giving vines. Both took an active role in colony affairs and activities, especially with Rugby's children. Many early Rugby houses had boardwalks right up to their front doors.

Though Thomas Hughes could not live in Rugby, his elderly mother, Margaret Hughes, became determined to join her son's new colony in America. She brought her teenage granddaughter, Emily, to join her father, Hastings Hughes. This picture was taken in England shortly before they set sail on the steamer *Illinois* in May 1881 with through passage to Rugby, Tennessee.

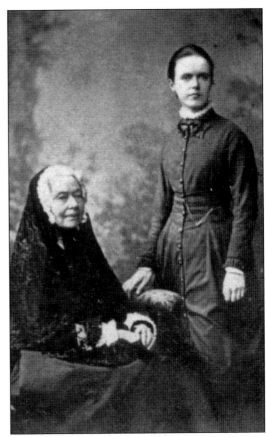

The Hughes ladies stayed at the Tabard Inn until Uffington House, shown below in a London *Graphic* engraving, could be made comfortable. When they reached Philadelphia, newspapers there printed: "It is not often that an octogenarian is willing to leave a comfortable home in England to cross the ocean as an emigrant from pure choice; but Mrs. Margaret Hughes, the mother from whom the well-known Thomas Hughes inherits his enthusiasm, has made such a choice. She will proceed to Rugby, Tennessee, the 'agricultural colony' founded by her famous son, 'to meet the needs of young men for whom there seemed to be so few avenues of success amid the crowded population of England.' "

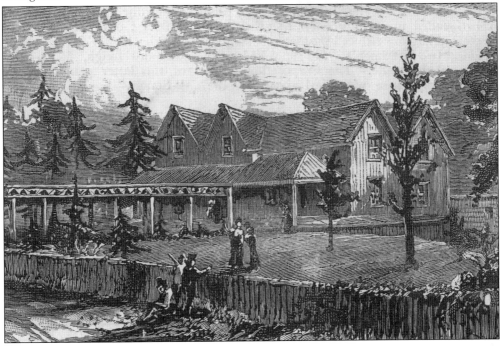

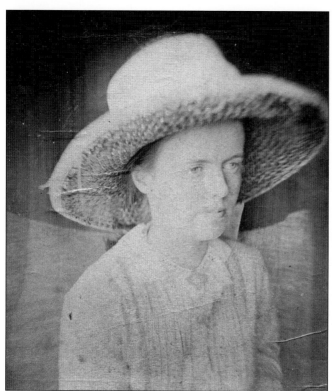

Letters written by Emily Hughes while in Rugby chronicle her love of the place and interesting and productive life there. She taught herself photography, learning about the chemicals required from the resident geologist, Charles Wilson. One of her letters describes how she took this self-portrait on the Uffington veranda in 1882.

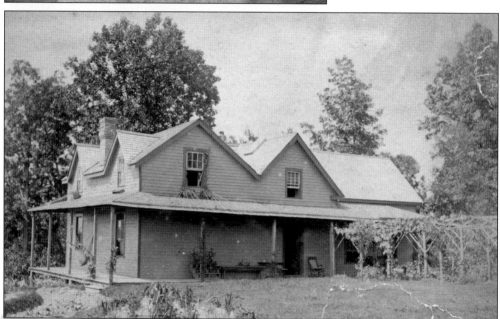

Uffington House was built in stages from 1880 to 1883. This 1884 photograph taken by Emily Hughes shows the completed house and some of the grounds that were carefully tended by the two ladies and the gardener they brought with them from England, "old Dyer." The arbor or pergola leading down to the front door was first planted in grapes, then later in climbing roses and vines.

Emily Hughes took many pictures of groups of residents and visitors, pasting the best ones into an album she called her "Story of Rugby." The group pictured here includes Robert Walton, standing at top right. The bearded gentleman seated at right is believed to be Dr. Charles Kemp.

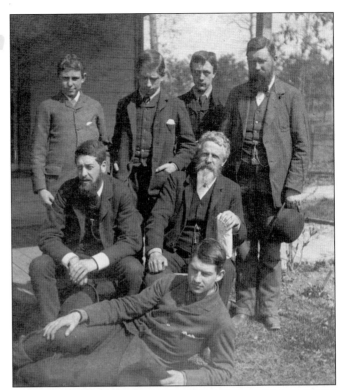

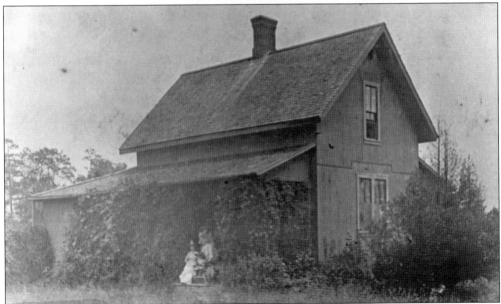

Dr. Charles Kemp, a physician who came from Boston to Rugby for his health in 1880, had Villa Ray built on a knoll that commanded mountain views. He quickly found himself pressed into medical practice again and worked heroically to save everyone who was stricken by typhoid in the summer of 1881. Kemp became well-known for growing high-quality wine grapes and was one of the most dedicated members of the Rugby community. He remained in Rugby until his death in 1892. Villa Ray stands today much as when it was built.

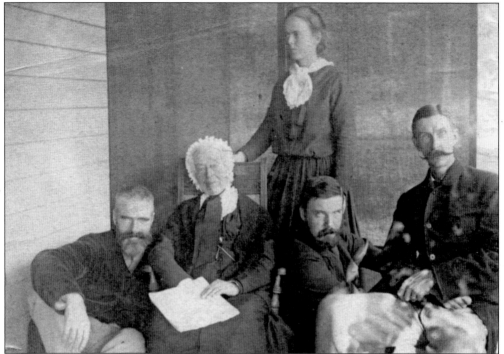

From left to right in this portrait on the Uffington veranda are Hastings Hughes, Margaret Hughes, Emily Hughes, and two unidentified men.

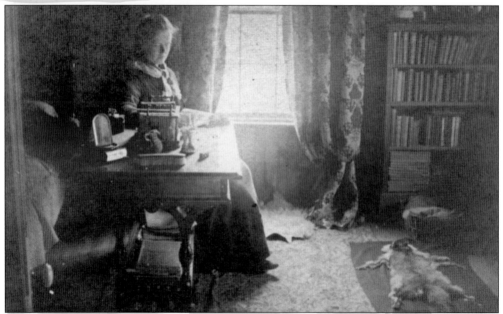

Shortly after the Hughes ladies arrived in 1881, a typhoid epidemic struck Rugby. Eight young men died, and some of the early colonists left. Emily, too, was stricken, and Margaret Hughes's letters describe the extraordinary efforts her father and Dr. Charles Kemp made to save her life. As she slowly recuperated, she described herself as "near bald" in one of her letters, probably written at this table in her bedroom.

Skilled architect-builder Cornelius Onderdonk and his wife, Jessica, came to Rugby from Indiana in 1881. He became deeply involved in the life of the new colony and, over seven years, built some of its most important buildings. The early newspapers are full of his advice columns, weather records, scientific experiments, and even poetry that extols Rugby's natural beauty.

Rugby's monthly, then weekly, newspaper was one of the first community papers in the region and was definitely the most intellectual and witty. It was first named the *Rugbeian* and published by a combination of early colonists, including Hastings Hughes and Osmond Dakeyne. Dakeyne became its editor but a few months later was the first to die of typhoid in August 1881. Other publishers continued the paper through 1887 with name changes—*Rugbeian and District Reporter* and *Plateau Gazette and East Tennessee News*.

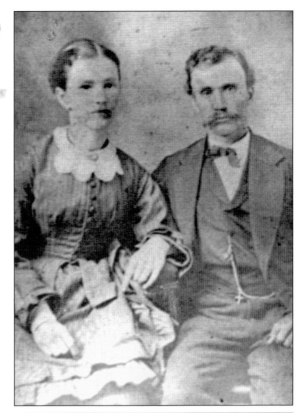

THE RUGBEIAN.

"SHOULDER TO SHOULDER."

No. 1. RUGBY, MORGAN CO., TENN., SATURDAY, JULY 2, 1881. PER FIVE

The Rugbeian.

RUGBY, MORGAN CO., TENN.,
SATURDAY, JULY 2nd, 1881.

"The Rugbeian" is published weekly at the Publishing Offices, Central Avenue, Rugby, Morgan Co., Tenn.

ITS AIMS.

1st.—To promote a cordial feeling of brotherhood not only between the two divisions of the English-speaking race, but also between the different sections of this country.

2nd.—To let all interested know, from time to time, how Rugby is getting on; what the Rugbeians are doing and thinking about, and what they can say as to the prospects of the settlement and neighbourhood.

3rd.—By discussion in a broad spirit to face any differences of opinion that may arise, affecting the welfare of Rugby, and by such discussion to arrive at any rate at an amicable agreement to differ.

TERMS:

Three Months	$1.00 Post paid.
Six Months	1.50 "
Twelve Months	2.50 "

Our English friends can remit by registered letter, or P.O.O. on Cincinnati, Ohio.

ADVERTISING RATES.

One Inch, per Insertion	$ 1.00
" Three Months	10.00
" Six Months	15.00
" Twelve Months	25.00
Quarter Column, Three Months	20.00
" Six Months	35.00
" Twelve Months	45.00
Half Column, Three Months	30.00
" Six Months	50.00
" Twelve Months	80.00
Whole Column, Three Months	45.00
" Six Months	80.00
" Twelve Months	100.00

TERMS CASH.

Address
EDITOR RUGBEIAN.

How are we getting on? Are we succeeding? What is the prospect for the future? must be questions constantly recurring to the mind of every true Rugbeian.

How they ring the changes on these all absorbing questions:—questions full of grave and vital interest, to the many settlers here. Questions, however, that are satisfactorily answered, in nine cases out of ten.

It is true that the onward growth was retarded by gross and culpable mis-management, yet no impartial observer can pass through Rugby to-day, without being fairly astonished, at what has been done on these wild Cumberland mountains in the short space of ten months.

The various streets of the Town site are being rapidly lined with neat frame buildings, and all through the long summer day the oft recurring ring of the hammer falls upon the ear.

Nor is individual enterprise lacking, for new industries are daily springing up around us; notwithstanding the want of sympathy and assistance on the part of the Board of Aid.

The failure of Rugby, whatever the fate of the Board may be, is now an impossibility, for there is far too much money invested in it and far too many clear-headed determined men ready to take it up and push it forward to success, should the necessity ever arise.

Of course it is very easy for irresponsible individuals to prophecy failure; and, when the individual is not only irresponsible but idiotically gullible, it is even

Can nothing be done to put a speedy end to this really disgraceful state of affairs!—for it is disgraceful that the large number of churchmen here should have been content to let Sunday, after Sunday, pass without making a determined and united effort to obtain a resident Pastor.

"It is never too late to mend," let all be united now; and let each of us enter a firm resolve that he will not rest content until this grave error has been rectified.

We publish in another column a letter from a correspondent complaining, somewhat bitterly, of the various noises that disturb the peaceful repose of respectable citizens.

We fear that he has some very just grounds for complaint; and can only hope that Mr. C. A. Clark, as soon as he is officially appointed sheriff, will look into this matter and oblige misguided youths to employ the daytime for exhibiting the power of their lungs.

Still "boys will be boys," and one must not be too hard upon them. The stern reality of work in a new colony, will soon knock all that sort of nonsense out of them. While the few idle, worthless, loafers will very soon learn that Rugby is no place for them and drift back to the (for them), more congenial atmosphere of "'Appy 'Amstead" and the third rate Music Hall.

WHEN, in May last, on the occasion of

the steps that have recently been taken to celebrate the 4th of July.

Every American knows what Independence Day means, the day on which our country finally burst the chains with which the then despotic Government of England sought to fetter her liberty. Here, in Rugby, on the Anniversary of this day we see young Englishmen vieing with their American brethren in making preparations to mark the day as one of pleasure and rejoicing.

The chief event that will take place on the Fourth is characteristic of the Anglo-Saxon race—Athletic Sports.

A few days ago a Public Meeting was held in the School to take steps to ensure the success of these Sports, and the following gentlemen, some English and some American, were elected to take what steps they might deem necessary:—

President—W. H. Hughes.
Vice-President—J. H. Blacklock.
Time-keepers—C. P. Kemp & R. Walton.
Umpires—A. E. Maude & P. H. Nairn.
Starter—Osmond Dakeyne.
Referee—J. Clarke.
Committee: C. A. Clarke, W. S. Emory, J. Milnaw, C. H. Wilson, J. S. Winkley.
Stewards: H. D. Boyle, A. B. Earle, F. Fisher, W. Hodgkinson, J. Jellicorse, E. H. Lawford, F. S. Swift, W. C. Robinson.

The price of programmes has been fixed at 5cts.; entries, 25cts. for two events, 50cts. for three, or $1 for the whole.

At a subsequent Meeting of the Com-

As Rugby grows and thrives tion of the amount of capital re making a successful start as there is agitating the minds of tending settlers, and some solid all-important problem has b essential necessity.

Some little time ago an a published in the "Monthly I naming the sum of £500 as amount with which to start in t this statement declares that th then expressed on the subject correctly stated; but, be that sum named was totally inade the sooner the question is impartially ventilated the bette for all concerned.

Careful inquiry amongst working portion of the commu steady observation of the resul labors, indubitably points out t (£1,000 sterling) is the sum o young Englishman might start Rugby or its vicinity with a f of ultimate success.

As general statements and assertions are, however, always it has been considered advisab a tabulated statement of the r quirements of those taking u this part of the United State however, be fully understood figures have been drawn up t requirements of the ordinar settler that is coming out (a class for which the Board a catering), namely, the sons o

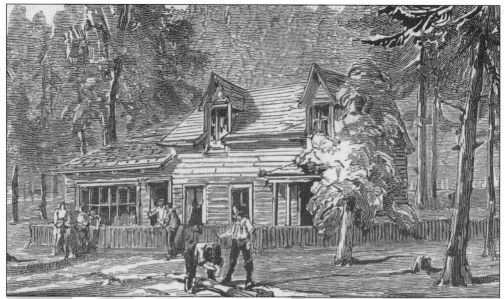

Thomas Fardon was active in several businesses in Rugby. The building shown in this London *Graphic* drawing served as both his home and his drugstore business, which was much advertised in the Rugby newspapers. An early advertisement lists some of the patent medicines carried, including Hall's Balsam, Pinkham's Compound, Allcock's Plasters, Winslow's Syrup, American Liniment, Ayer's Pills, and Bull's Worm Candy. Fardon also published the newspaper in this building for several years.

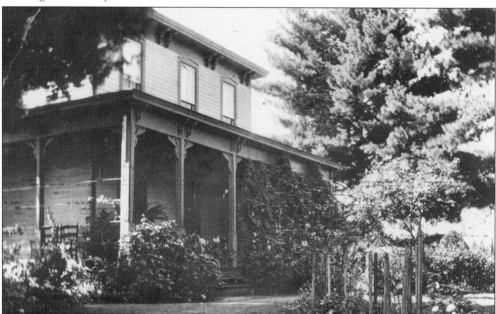

Twin Oaks was called "The Mansion House" by Rugby residents and was one of the largest homes built in early Rugby. Beriah Riddell from Kentucky constructed it. He shows up often in the Rugby newspapers, carrying out all types of building projects for other colonists. He and his wife, Mary, gave lavish parties at Twin Oaks, some to the music of hired bands. Twin Oaks survives today and has been restored.

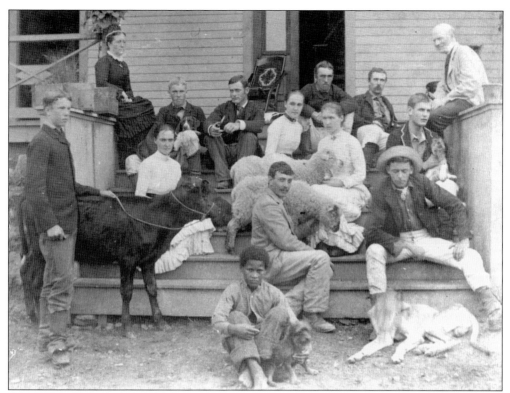

During his 1882 visit to Rugby, Thomas Hughes, shown seated at upper right, visited the Marshall family at their home, Kenmore, near the Rugby village. This scene with its farm animals and young African American boy seems to illustrate Hughes's utopian hopes for Rugby. His niece, Emily, was to marry Ainslee Marshall, shown seated directly in front of the open door.

The Tabard Inn was shut down after the typhoid epidemic, "cleaned from cellar to dome," according to Rugby's newspaper, and a new manager sought. A very experienced hotel man, Abner Ross, took it over in May 1882. Ross had owned three different hotels in Ohio and had also been manager of the famous Palmer House in Chicago. He apparently did a good job and attracted many visitors by promoting Rugby as a beautiful and healthful destination.

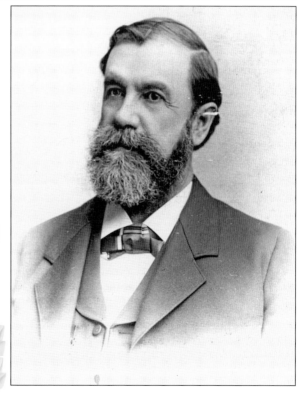

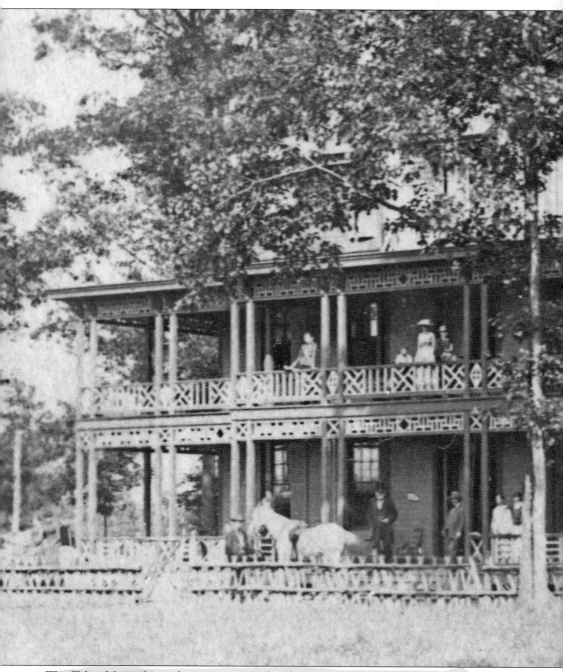

The Tabard Inn, shown here in its 1884 heyday, was the social center of Rugby. Dozens of accounts in the newspapers report on dinners and dances, children's parties, billiard games, teas, lawn-tennis games, and croquet. Ross's advertisements touted "the healthful mountain air and

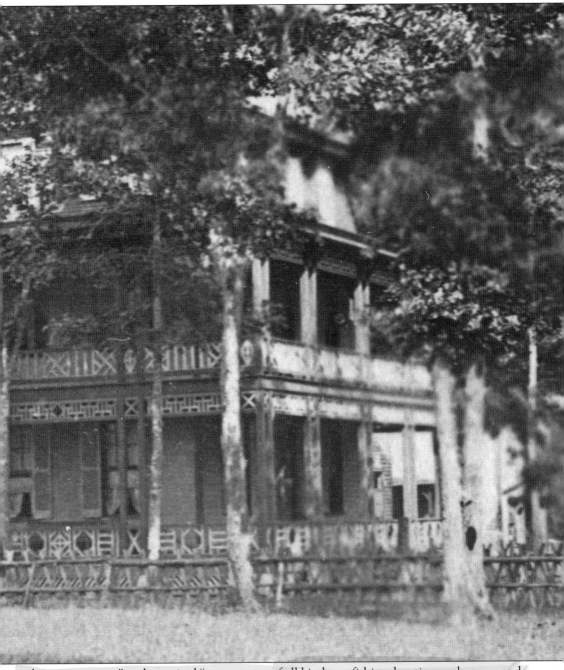

charming scenery" and promised "amusements of all kinds . . . fishing, hunting, archery . . . and a park with deer and other pets for children."

The Gardens Cottage was built from a design published in the *American Agriculturist*. It was adjacent to the Tabard and initially was home to hotel managers, then to various guests. In 1884, it became the home of Englishman William Henry Gilliat and his family, who remained here until it burned in 1912. Mrs. Ellen McDaniel Gilliat, a Southern lady from Clarksville, Tennessee, is standing on the entry porch, flanked by her daughters, Leila and Clara.

A family named Fowler from New York built this home in 1882 and named it the Pines. Like many residents in early Rugby, they maintained extensive Victorian gardens and followed the practice of training vines to shade the veranda. The home burned in 1899.

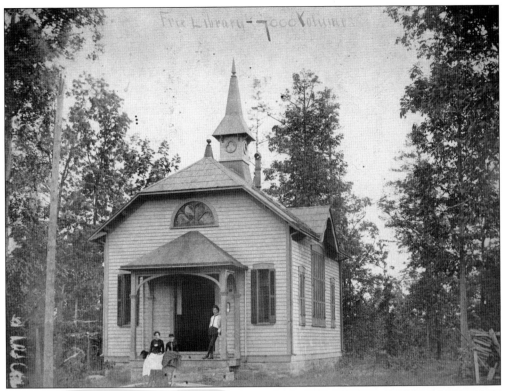

By far the biggest event in Rugby in 1882 was the building and opening of the Thomas Hughes Free Public Library, shown here with several patrons in front. Carpenter John Winkley was working on the building when he died; his wife oversaw its completion. October 5, the second anniversary of the opening of the colony, was chosen to open the library, and a large crowd was in attendance.

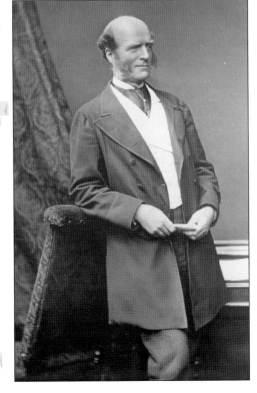

"Madame" Margaret Hughes, as the colonists respectfully called her, presented this photographic portrait of her son Thomas Hughes to the Hughes Library when it opened. It still hangs there today.

Edward Bertz, a young German scholar and political dissident, arrived from England in July 1881 after learning about Rugby and its social reform goals. He brought his Highland collie and his personal library and was bent on learning to farm. After enduring a hard winter in a small cabin in the woods, he promptly agreed when asked to be the librarian.

This is the only library interior photograph known from the early 1880s. Seated at the table in front is Mary Percival, who succeeded Bertz as the librarian, and geologist Charles Wilson. Mrs. Percival's daughter, Alice, is on the ladder. Bertz laboriously produced a handwritten catalog of the 7,000-volume collection, which survives today.

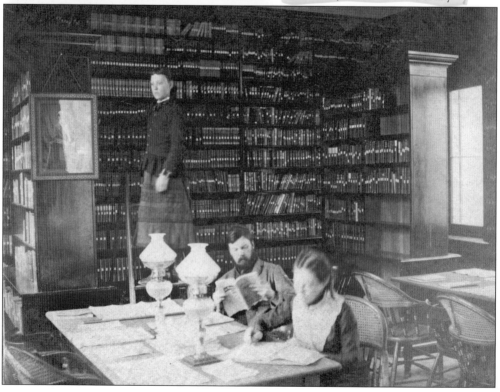

Three unidentified boys of early Rugby enjoy a day at the river. They seem young to have loaded guns so may be pretending.

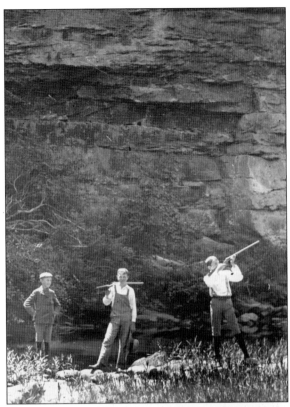

Emily Hughes probably took this photograph in March 1883, as the newspaper reported then that Sir Henry Kimber was visiting the colony for the first time. He was one of Hughes's Boards of Aid members and an important financial backer of Rugby. From left to right are (first row) unidentified and Henry Kimber; (second row) Robert Walton, James Milmow, and unidentified.

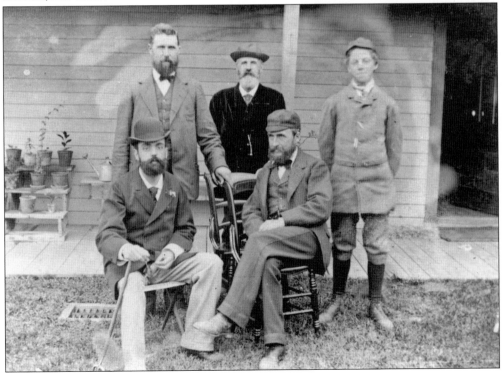

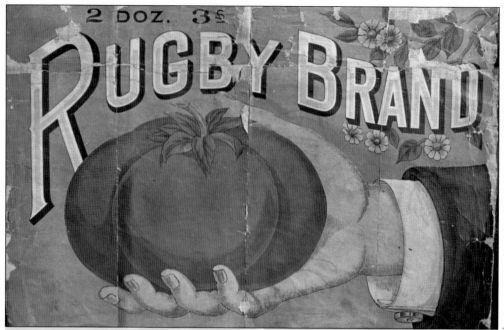

Several agricultural businesses were attempted in the 1880s, but few succeeded more than briefly. Six Rugby men established the Rugby Canning Company in 1882, shipped in steam-operated boilers and equipment from Cincinnati, and had these labels printed. Unfortunately not enough tomatoes were raised to make the operation feasible. The cannery building became a successful steam-operated laundry run by Hattie Shelby, an African American member of the community.

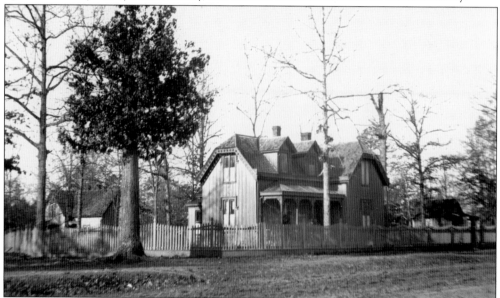

Though he could not live in Rugby, Thomas Hughes was determined to show his support in every way possible. He commissioned Cornelius Onderdonk to construct this charming Gothic-style cottage in 1884, used it only a few times during his annual visits, and rented it for a nominal fee to Joseph Blacklock, the first Christ Church rector. The cottage for Henry Kimber, at left, was built at the same time.

42

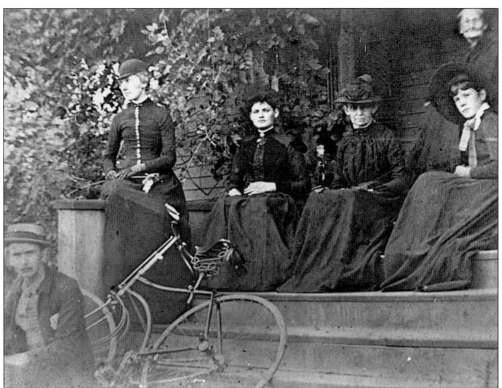

These unidentified ladies and a gentleman with a bike visit at the Yandilla veranda in the 1880s. Englishman Frederick Fisher, who later became an American citizen, built the house. The veranda surrounded all four sides of the house. Yandilla burned in 1899.

The Board of Aid published the *Rugby Handbook* in the summer of 1884, during a period when the Rugby colony's fortunes seemed to be rising. The booklet is a detailed look at virtually every aspect of the colony and its setting. About the Tabard Inn, it states: "Rugby has an excellent hotel. [It] stands in a commanding position overlooking the Clear Fork River and . . . strikes the observer as being far above the average pleasant country resort."

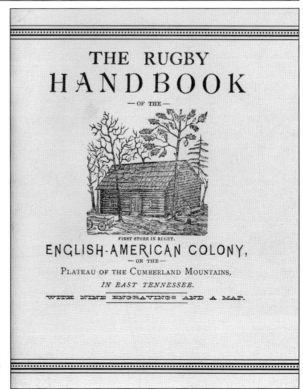

THE RUGBY

HANDBOOK

— OF THE —

FIRST STORE IN RUGBY.

ENGLISH-AMERICAN COLONY,

— ON THE —

PLATEAU OF THE CUMBERLAND MOUNTAINS,

IN EAST TENNESSEE.

WITH NINE ENGRAVINGS AND A MAP.

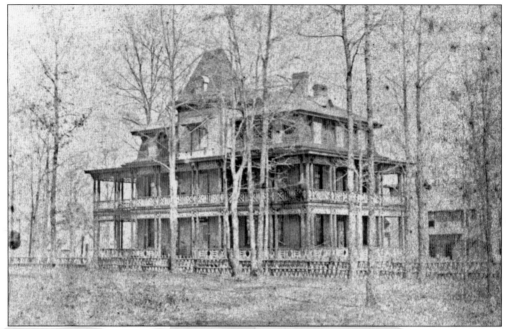

"Great Conflagration! Tabard in Flames!" read the headline of the October 17, 1884, issue of the *Rugbeian and District Reporter*. Calling the fire "the most terrible disaster in the village of Rugby," the paper reported that the apparent cause was a chimney fire. Residents rushed to the scene and began saving furnishings before the building was consumed. The Tabard's loss clearly hurt Rugby's future.

Life went on in Rugby but without the large numbers of visitors the Tabard had been attracting. This scene on Central Avenue shows Robert Walton (far right) visiting with other residents. Just visible in back, from left to right, are the Board of Aid building, the Commissary, and C. N. Tribby's store.

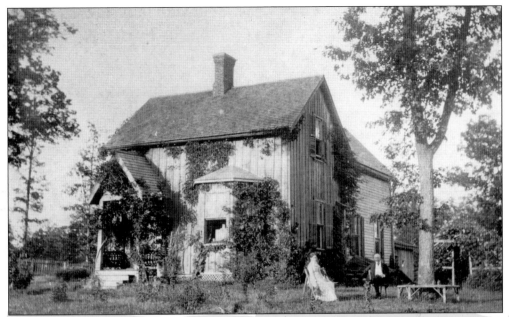

Otis Brown, brother of Ross Brown of the Brown House Hotel, built part of Adena Cottage in 1880. Soon afterward, it was sold to Frederick Wellman, an Englishman who had been living in America. His wife was the former Sarah Worthington Pomeroy, a granddaughter of Gov. Thomas Worthington of Ohio. She named it Adena Cottage for the now-restored family mansion in Chillicothe, Ohio. Sarah Wellman filled Adena Cottage with family heirlooms.

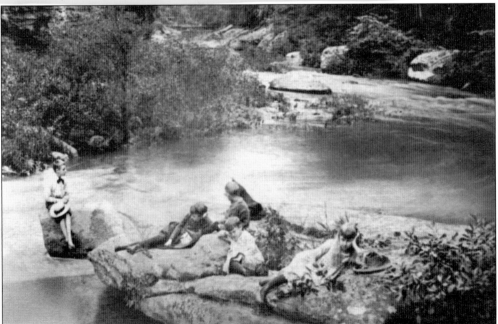

Vivian Gilliat, sitting on the rock at left at the Meeting of the Waters, was around 12 in this 1886 photograph. His twin sister, Clara, is at far right. The other three children are unidentified. The Gentlemen's Swimming Hole was another favorite destination for children and adults. It was about a mile upriver on the Clear Fork.

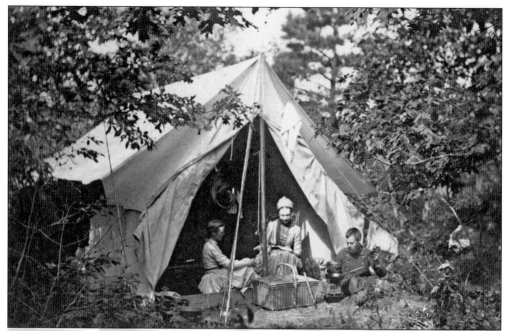

Emily Hughes's brother Harry came for a visit in 1886 after working for several years on their brother's sheep farm in Texas. He set up this camp for fun or because Uffington was full. Perhaps Emily, at left, has brought him the picnic basket. The lady in the middle is unidentified. Emily writes in one of her letters that Harry was to come back and stay to help her start a dairy operation when the new Tabard hotel was completed.

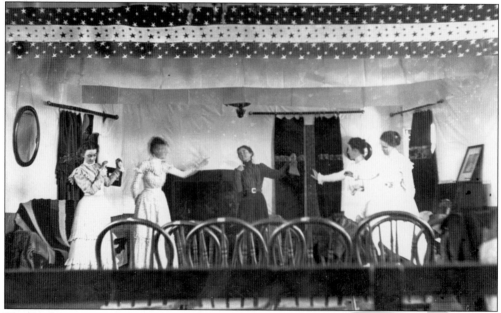

The Rugby newspapers report many entertainments presented by the Rugby Social Club. This photograph captures a play in progress. From the reports, it seemed that virtually every resident in the village and surrounding area had talent and shared it by singing, dancing, acting, instrument playing or just performing theatrical readings. Ladies often portrayed gentlemen and vice versa.

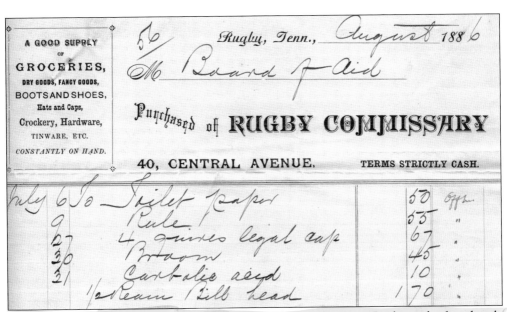

A GOOD SUPPLY
OF
GROCERIES,
DRY GOODS, FANCY GOODS,
BOOTS AND SHOES,
Hats and Caps,
Crockery, Hardware,
TINWARE, ETC.
CONSTANTLY ON HAND.

Rugby, Tenn., *August* 188 6

M *Board of Aid*

Purchased of **RUGBY COMMISSARY**

40, CENTRAL AVENUE. TERMS STRICTLY CASH.

July	6	To Toilet paper	50	Office
	9	Rule	55	"
	27	4 quires legal cap	67	"
	30	Broom	45	"
	31	Carbolic acid	10	"
		1/2 Ream Bill head	1 70	"

The Rugby Commissary remained the primary retail general store in Rugby as the first decade progressed. The post office was also there, making it a popular gathering place. This invoice lists toilet paper for 50¢, a broom for 45¢, and carbolic acid for 10¢.

Both colonists and visitors to Rugby enjoyed the beauty and outdoor challenges of the surrounding Clear Fork and White Oak River gorges. Here an unidentified group poses in the 1880s at one of the sandstone cliffs so extensive along both rivers. The trails built by early colonists down into these gorges have been maintained through the decades and are still in use today.

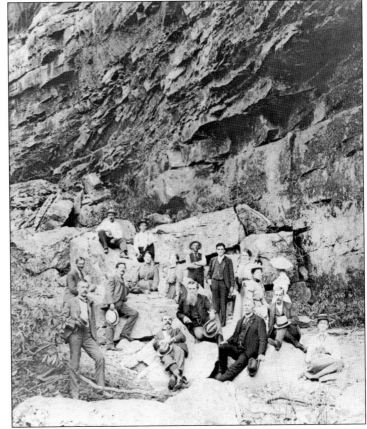

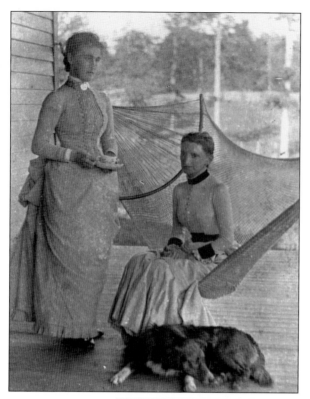

Mrs. Richard Tyson, right, and her daughter are enjoying a cup of tea on the back veranda of Roslyn. Montgomerie Boyle built Roslyn in 1886. He rented it to Mrs. Tyson of Baltimore, who brought her marriageable-age son, Jesse, and daughter, Sophia, to Rugby and held many parties and dances in the home. Emily Hughes's letters describe pleasant visits and parties at Roslyn.

After much comment in the newspaper about the need, the Hughes Board of Aid finally found a way to fund construction of another Rugby hotel, again naming it the Tabard. The second hotel opened in 1887 on the same foundation site as the first but was never a financial success for the dozen or more proprietors who ran it. It too burned in 1899.

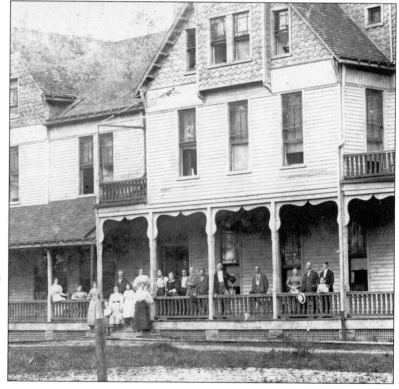

Margaret Hughes's letters in 1886 and 1887 begin to speak of her age and infirmity and her concern for what will become of granddaughter Emily when she dies. "Emily will marry," she writes, "unless all men are bigger fools than I take them for." In early 1887, Emily wrote a friend in England that she was engaged to Charles Wilson but that they wouldn't marry for some time, as he was in British Honduras on a geology expedition.

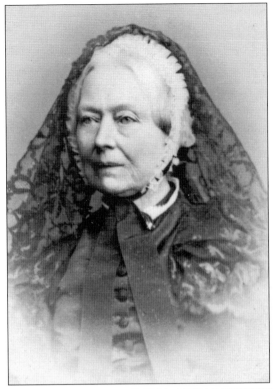

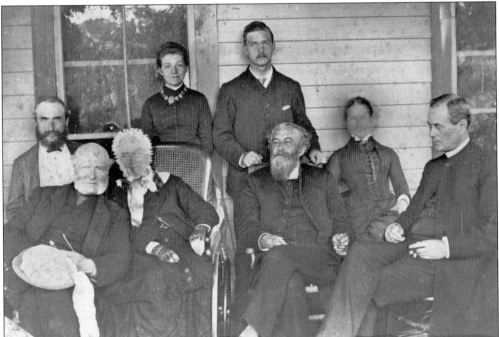

This rare picture of Thomas Hughes, seated at left by his mother, may have been taken in 1887 on Hughes's last visit to Rugby. Sir Henry Kimber is seated behind Hughes. Rev. C. V. Adams is seated at far right. The other bearded man is Joseph Blacklock. The others are unidentified.

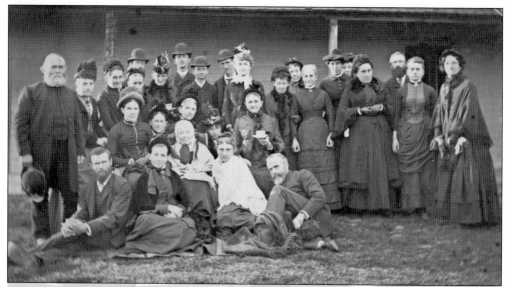

A large group gathered for Margaret Hughes's 90th birthday party in September 1887. Emily organized and took this picture. From left to right are (first row) Harry Hughes, Mrs. Blacklock, Margaret Hughes, Sarah Forbes Hughes (Hastings's new wife), and Hastings Hughes; (second row) Rev. Joseph Blacklock, Mrs. Walton, Mrs. Wellman, and Mrs. Onderdonk. Some of the others known to be in the picture include Ainslee Marshall, Jesse Tyson, Mrs. Percival, George Berry, Leonard Mytton, Elizabeth Hadden, Mrs. Potbury, Mrs. Chamberlain (the schoolteacher), Louise Dyer, and Maggie Dyer.

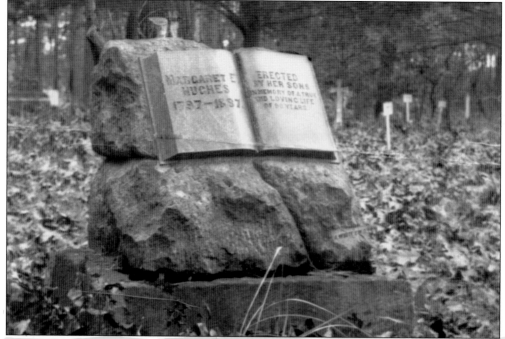

Margaret Hughes died on October 5, 1887, the seventh anniversary of the colony her son founded and she so staunchly supported. Her gravestone at Laurel Dale Cemetery is solid granite. The inscription reads: "Erected by her Sons, In Memory of a True and Loving Life of 90 Years."

Margaret Hughes's funeral was the last ceremony conducted in the joint schoolhouse and church. Most of the British colonists and others were of the Episcopal faith and finally collected some $1,800 to build their own church. Cornelius Onderdonk drew up and built this classic Carpenter Gothic structure.

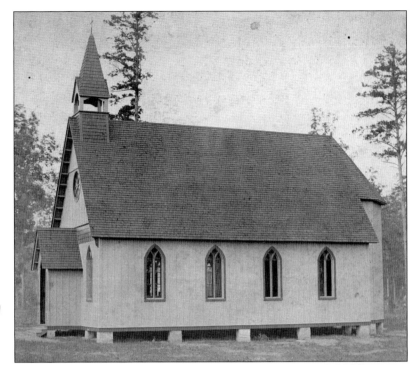

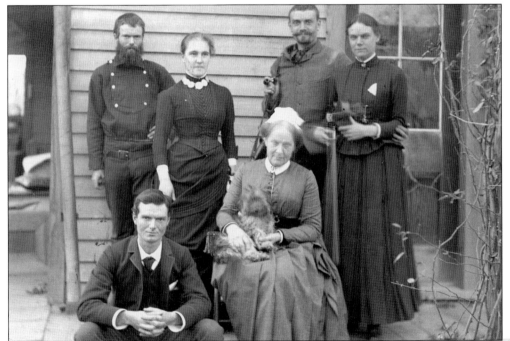

One of Margaret Hughes's closest friends in England was Mrs. Tom Taylor, seated here on Uffington's side veranda. She and her son and daughter had long planned a visit to Rugby but arrived two days after Margaret Hughes died. Emily's brother, William, is seated next to her. Standing from left to right are Harry Hughes, Helen Turner, Wycliffe Taylor, and Lucy Taylor. It was to Lucy that Emily Hughes wrote many letters from Rugby.

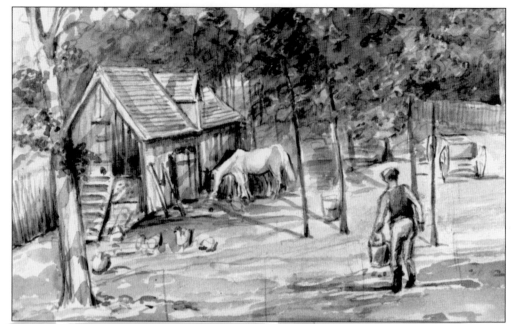

After Margaret Hughes's funeral, the Taylors stayed in Rugby with Emily Hughes for several weeks, during which Mrs. Taylor created several dozen small watercolor paintings. A diary kept by Lucy tells of their experiences visiting and exploring around the village and surrounding area. This painting shows Emily's barn and fowl house.

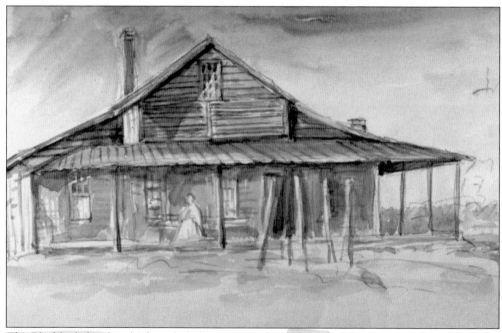

The Blacklock family, which included seven sons, had a home on the western edge of the town site. It was described as being built of logs and was probably larger than it appears in this painting. Mrs. Taylor also painted the expansive view of the Cumberland Mountains from the rear of the house.

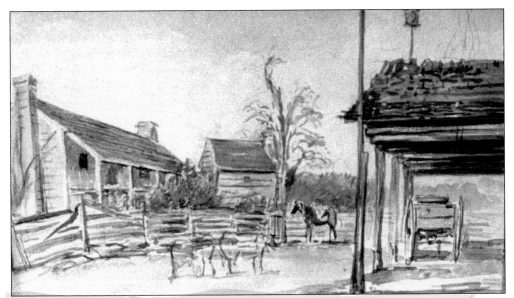

Mrs. and Mrs. Isaac Riseden were in the Rugby area long before the colony was established. They created a beautiful farm where the White Oak River makes a sharp bend and named it Horseshoe Bend. They had provided much support and advice to the new colonists in the early 1880s. Mrs. Taylor visited with them and painted this watercolor of their log home and other buildings.

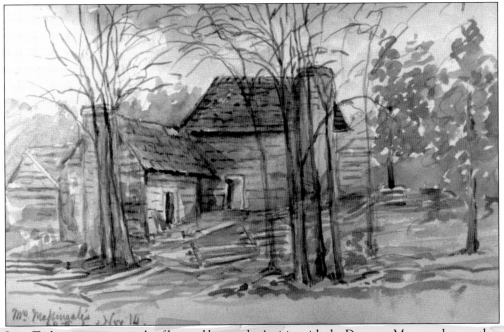

Lucy Taylor wrote extensively of her and her mother's visits with the Dempsey Massengales, another family whose homestead preceded Rugby by several decades. This record of the Massengale log cabin is the only surviving image and is being used to develop an outdoor exhibit at the site today. Dr. John DeBruyn discovered Mrs. Taylor's watercolors in a trunk in Ireland.

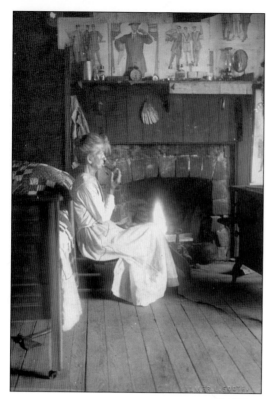

A photograph does survive of inside the Massengale cabin. In it, Mrs. Elizabeth Massengale's sister, Betty Lowe, is smoking her corncob pipe at the fireplace. Note the hatchet under the bed, a practice that has several different folk definitions, usually relating to childbirth.

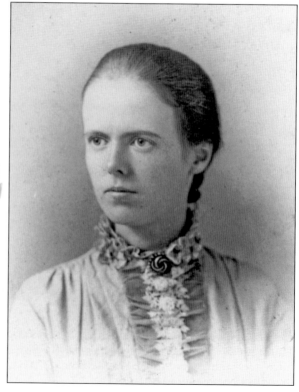

Emily Hughes left Rugby mourning not only her beloved grandmother, but also her fiancé, Charles Wilson. Just days before Margaret Hughes died, Emily received word that Wilson had died of yellow fever while still in British Honduras. Emily went to England to visit Wilson's parents, then came back to America, where she lived in Massachusetts near her father and his new family. She married Ainslee Marshall in 1902. Late in life, they followed their only son to South Africa to help him establish a coffee plantation. Emily died there in 1938.

This small booklet was printed and used to promote the new Tabard Inn in 1888. Two pages of prose include the following description: "The new Tabard, built on the site of the old inn, is a beautiful modern structure, accommodating about seventy-five guests, and elegantly furnished throughout, the rooms and passages being lofty and well ventilated. The table is well supplied: the aim of the proprietors being to furnish good food, well cooked. There is an elegant new billiard table and a dancing room in the hotel, and out-of-doors lawn tennis, croquet, and other games are engaged in."

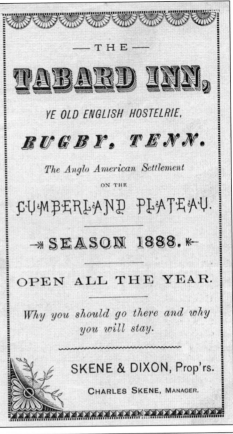

— THE —

TABARD INN,

YE OLD ENGLISH HOSTELRIE,

RUGBY, TENN.

The Anglo American Settlement

ON THE

CUMBERLAND PLATEAU.

→ SEASON 1888. ←

OPEN ALL THE YEAR.

Why you should go there and why you will stay.

SKENE & DIXON, Prop'rs.

CHARLES SKENE, MANAGER.

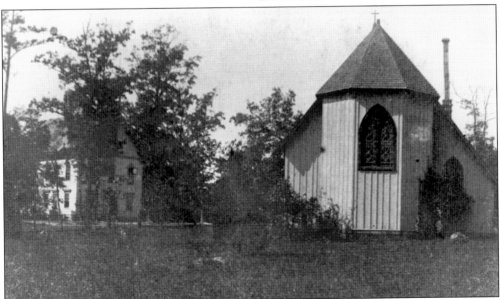

This rear view of Christ Church is the only photographic image known that shows the original three-story building constructed by the Board of Aid to serve as both school and church. The third floor became the Masonic Lodge.

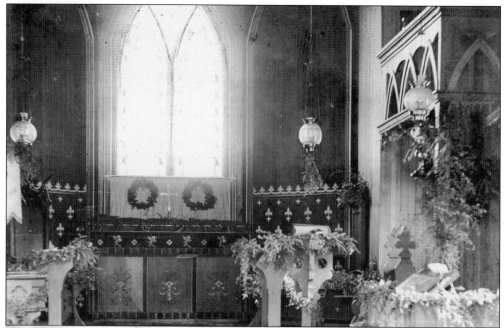

To date, this is also the only known historic photograph inside Christ Church, probably taken in the late 1880s. The beautiful hanging oil lamps that the Gilliat family donated are visible, as are the walnut altar furnishings handmade by Cornelius Onderdonk. The picture was probably taken to show the Christmas decorations of live greenery, long a British custom.

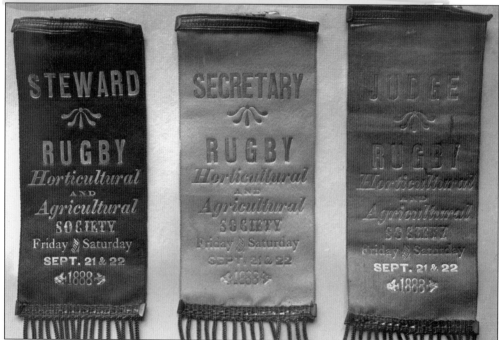

The newspaper records annual competitions sponsored by the Rugby Horticultural and Agricultural Society in the 1880s. Listed winners include many categories of farm animals, vegetables, and flowers. Some of the winners were from other communities developing around Rugby.

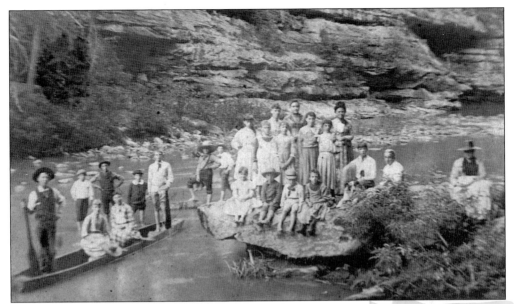

A recently discovered old newspaper article names almost everyone in this photograph taken in the late 1880s of a group picnic at the Meeting of the Waters, but not in order. In the boat, holding a paddle, is Sam Norris. The others include members of many Rugby families: Ida Mae Kellogg, Annie Berry, Sarah Wellman, Bessie Berry, Sarah Kellogg, Eleanor Wellman, Ellen Dimling, Clara Gilliat, Sally Staggs, Edith Walton, Kimber Walton, George Walton, Ida Alexander, Clark Kellogg, Vivian Gilliat, Charlie Wellman, Daly Alexander, and Don Kellogg.

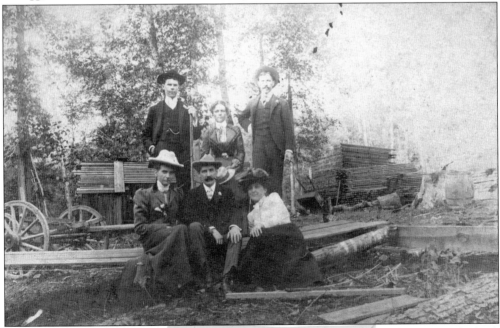

The names of people posing at one of Rugby's sawmills in the 1890s are written on the back of this photograph. From left to right are (first row) Jennie Oberheu, James Lourie, and Will Williams (believed to be short for Wilhelmina); (second row) Will Walton, Nan Shelton, and Charles Brooks.

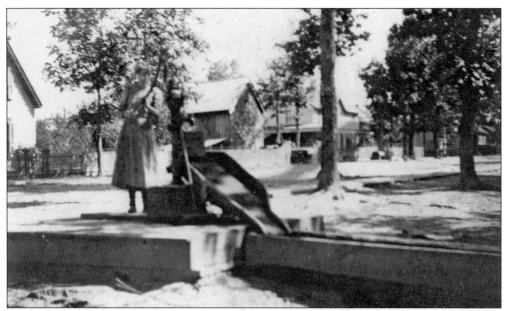

A young lady draws a bucket of water from the Rugby town pump in this photograph. At far left, the edge of Cornelius Onderdonk's home is visible. In the background is the Alexander/Perrigo boardinghouse to the right of its barn.

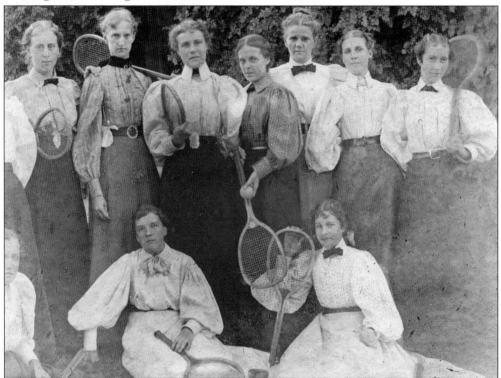

This photograph is dated September 19, 1896, on the back, but only a few of the young ladies in their tennis costumes are identified. At back left is Helen Turner; next to her Nelly Lender Oberheu, then Clara Gilliat. Fully visible seated on the left is Will Williams.

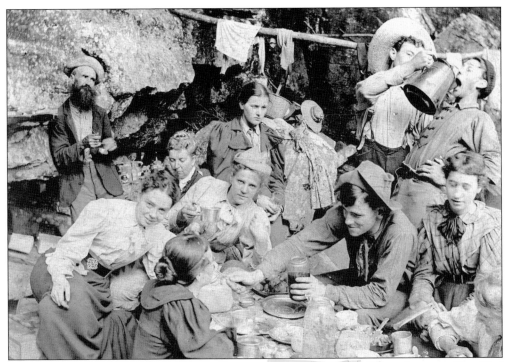

A very convivial group was photographed having a picnic at the river. The only person identified with certainty is Samuel G. Wilson, standing in back against the bluff.

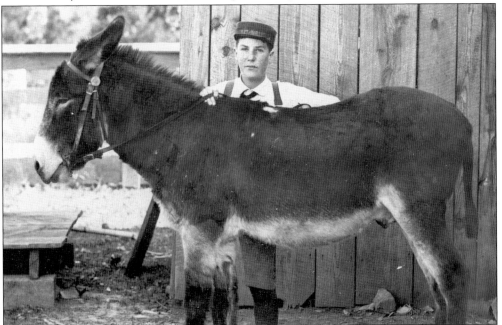

Robert Walton's son, George, is pictured with the Walton family donkey, named Tom. Many stories have been handed down about Tom Donkey. He was known for his ability to open everyone's gates and dine in their gardens, but he was also trained to pull a cart around the village to the delight of the children.

Margaret and Emily Hughes had been gone from Uffington House for nine years when this photograph was taken in 1896. A Mrs. Davis is watching Trixie Dimling, left, and Addie Davis play a game of croquet.

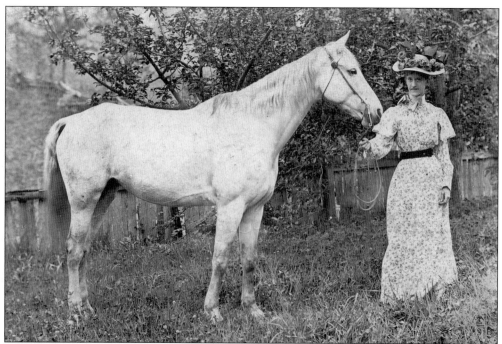

Nellie Lender Oberheu and her German family first lived in Wartburg, visited for a dance at the Tabard Inn, and then moved to Rugby. Nellie is shown here with her horse, Maid, in the 1890s.

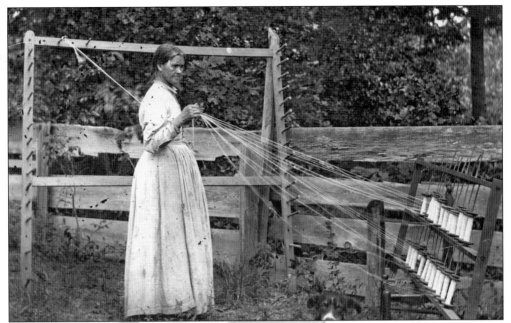

Rugby resident Laodicea Fletcher was a skilled textile artisan. She made her own dyes from roots and herbs, carded her own wool, spun her own thread, designed her own patterns, and wove on a loom she had carried across the mountains from her former home in West Virginia. She was an avid reader of the best literature and could copy the most intricate English weaving patterns. Some of her work remains at Rugby.

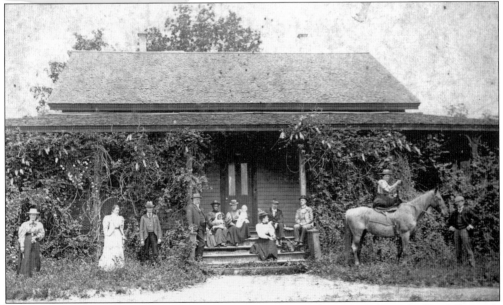

From left to right, starting with Robert Walton, the bearded man at left on the Yandilla porch stairs, are Hattie Shelby and child, Mrs. Maxwell Graham and her child, and Maxwell Graham. Sitting to the right of Graham is Ohio writer N. P. Runyan, whose 1900 book, *A Quaker Scout*, is set partially in Rugby. Sidesaddle on the horse is Mary D. Ritchie, who was later to marry George C. Semple, the man holding the horse. The others are unidentified.

Informal drama was a common pastime in the late Victorian era. This unidentified group in Rugby has staged an amusing scene for the camera.

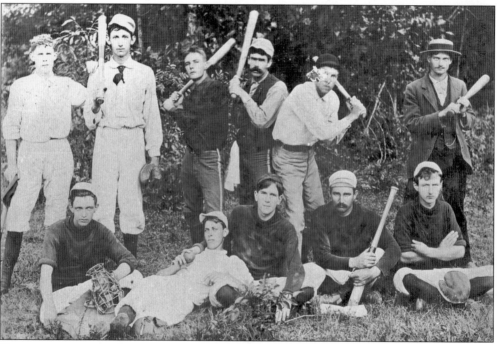

Newspaper accounts of sports activities in Rugby include details about the establishment of a baseball club in the 1880s. This picture was taken in the early 1890s based on the age of Vivian Gilliat, the third player standing from the left.

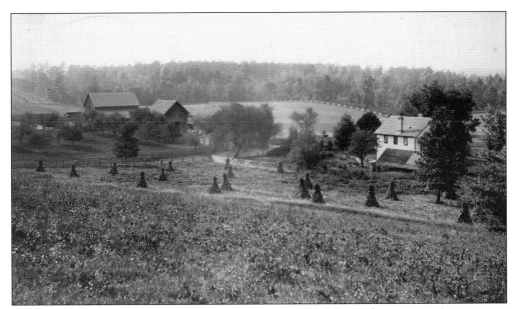

Few photographic records remain of the farms that surrounded the Rugby town site. An exception is this expansive view of Montgomerie Boyle's farm at Glades, about nine miles south of Rugby. His father was Scotsman John Boyle, one of the principals in the Board of Aid when Rugby was established. One of Boyle's accounts showed a harvest of 766 pounds of top-grade tobacco in 1885. This scene was photographed in 1891.

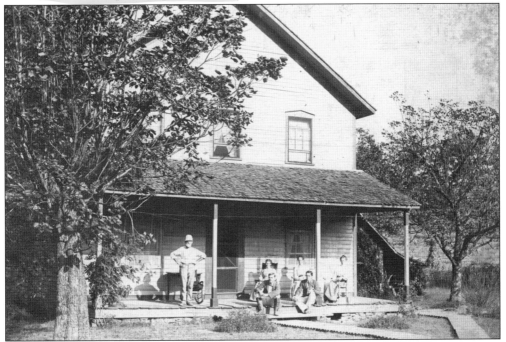

Thomas Taylor was an experienced farmer when he took over the running of Boyle's Glades farm in the early 1880s. He is standing on the left at the home he occupied with his family. His wife sits to the right of the door. The others are unidentified, but several are probably the Taylors' children.

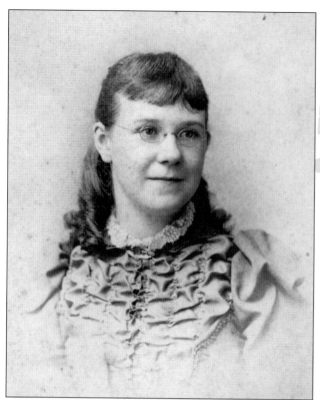

Esther Walton posed for this photograph when she was 13 in 1892. She was extremely bright and entered the University of Tennessee when only 15. During both high school and college, Esther wrote many stories about early Rugby that have survived and been published by Historic Rugby in a booklet called *The Hermit, the Donkey and Uncle Dempsey*.

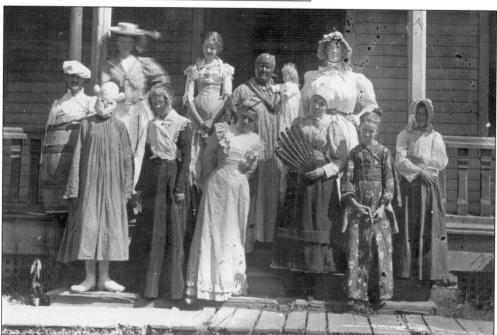

A group of costumed Rugby young people pose on the steps of the second Tabard Inn, probably before or after a Halloween party at the hotel. Note that the lady at the top right is likely a young man.

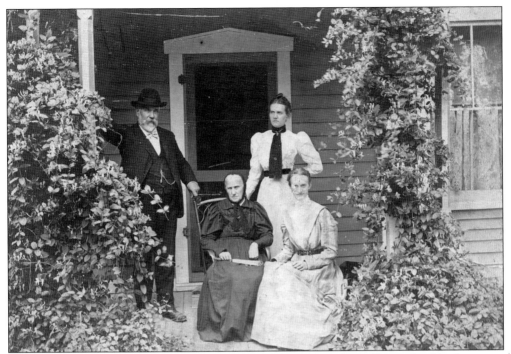

Robert Walton visits with Barbara Lender, the seated elderly lady; Nelly Lender Oberheu, next to her; and Jennie Oberheu on the porch of Grey Gables, which stood immediately east of Virgo House.

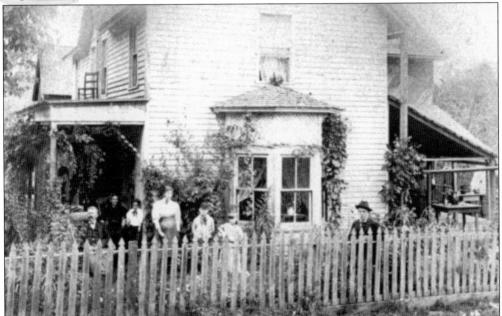

Samuel Alexander had run several businesses in the Rugby area before taking over this boardinghouse. Alexander is seated at far left in this 1890s photograph with his family around him. Virtually every residence in Rugby was enclosed by picket or board fences, both for neatness and to keep the wild hogs that roamed the area from destroying their gardens.

65

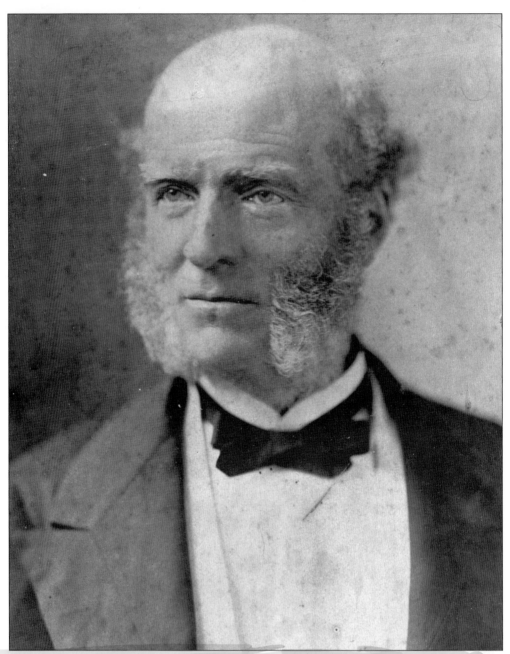

Thomas Hughes never returned to Rugby after his mother died in 1887. He and his London board officially sold their land and holdings to an American company around 1892 but did not recoup their significant losses. Hughes corresponded regularly with Robert Walton and Charles Kemp, always asking them to give his regards to various townspeople he had come to know and respect. In what appears to be his last letter to the colony, he expressed regret that at his age he would probably never be able to return to Rugby. "Good seed was sown when Rugby was founded," Hughes wrote, "and someday the reapers, whoever they may be, will come along with joy bearing heavy sheaves with them." Thomas Hughes died on March 21, 1896, while in Brighton, England, and is buried there.

Three

THE DREAM FADES
BUT RUGBY SURVIVES

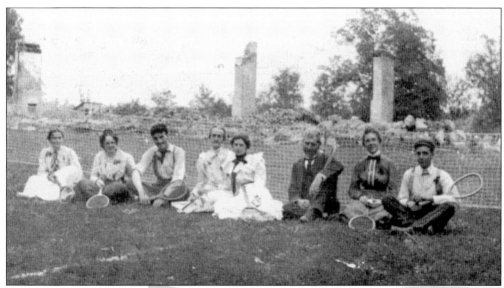

With Rugby past its heyday, the various proprietors at the second Tabard Inn seldom had adequate business. In 1899, it, too, burned from a chimney fire. Once again, many of the furnishings were saved before fire consumed the building. Residents continued playing lawn tennis on the court that had been marked off in front of the hotel. Building rubble can be seen in the background.

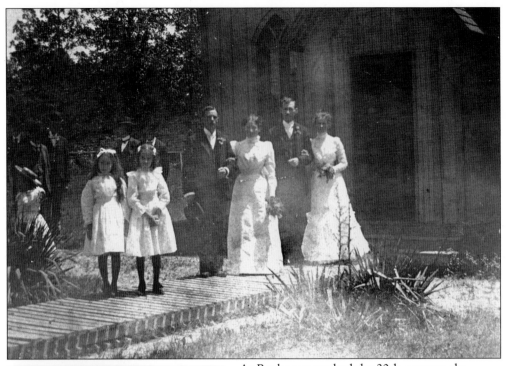

As Rugby approached the 20th century, the double wedding of the Gilliat twins was a big event on July 19, 1899. This picture of the wedding party in front of Christ Church shows Vivian Gilliat and his bride, Tina Tompkins, on the left, and Layton Hurst Young and bride Clara Gilliat on the right. Rev. William Robinson performed the ceremony.

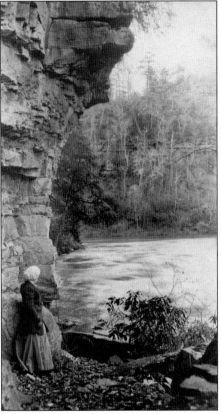

An unidentified lady stands gazing at the flooded Clear Fork and White Oak Rivers at the Meeting of the Waters around 1900, with the picnic ledges and rocks submerged and no longer visible.

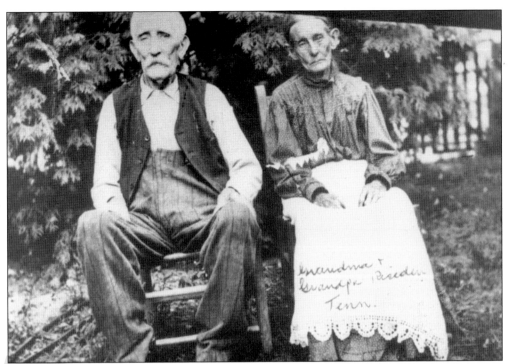

Isaac and Mary Jane Riseden, seen here around 1910, lived on at Horseshoe Bend into the 20th century. All their children received good educations, including their daughter Maude, the first woman to graduate from the University of Tennessee College of Law. The couple is still at Horseshoe Bend, buried together in the family cemetery.

Another wedding was celebrated in Rugby on April 24, 1903, when James Lourie wed Jennie Anne Oberheu. The couple is shown coming out of Christ Church Episcopal after the wedding. Rev. Alexander Killeffer performed the ceremony.

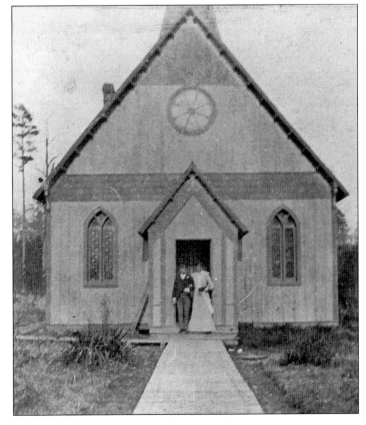

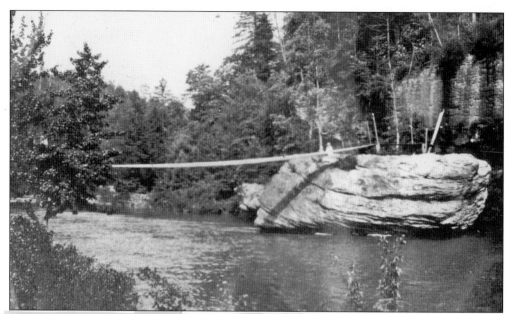

Several swinging bridges were built in Rugby's early years. This bridge was built across the Clear Fork below the Tabard Inn and was a popular destination for residents and visitors. One of the steel pipes that held the bridge in place is still visible today embedded in the huge rock at right.

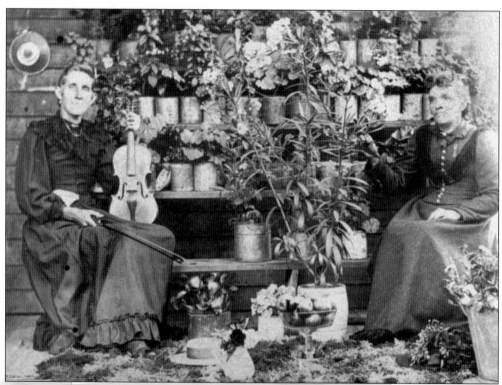

Ora Perrigo began running Samuel Alexander's boardinghouse around 1900. She is sitting at right with her many plants displayed on the porch. The lady with the fiddle at left is unidentified.

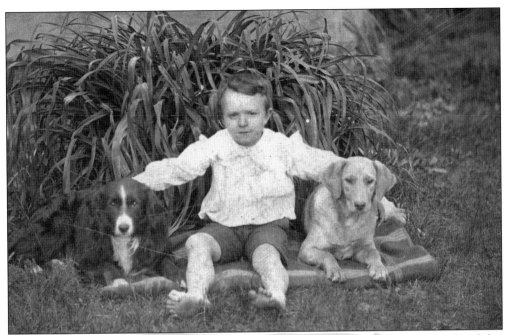

Ora Perrigo's grandson, C. Joe Galloway, lived with her for several years. He is pictured with his dogs around 1902. Galloway never forgot his grandmother, who is buried at Laurel Dale Cemetery, and his childhood days in Rugby. In the 1980s, he donated funds to Historic Rugby toward the possible historic reconstruction of the boardinghouse.

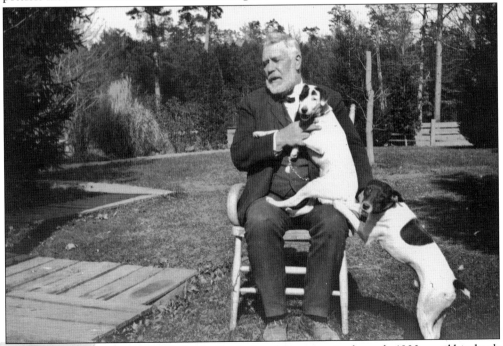

Robert Walton continued to work for the Rugby Land Company in the early 1900s until his death from heart failure in 1907. This picture of him with his dogs on the lawn of Walton Court was taken just a year or two before he died.

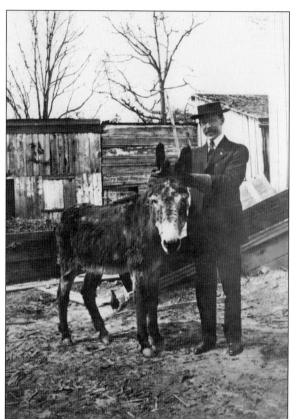

Tom Donkey was showing his age when pictured here with Will Walton around 1908. After his father died, Will came home to Rugby from his railroad surveying work, married Sarah Kellogg, and devoted the rest of his life to the Rugby community.

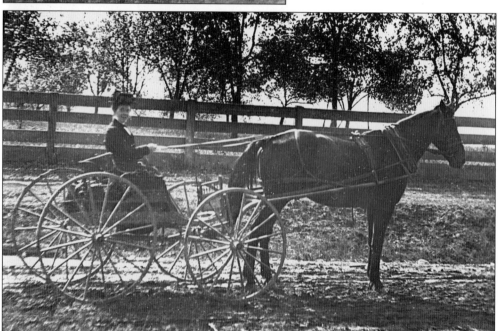

This photograph shows Esther Walton out for a drive around 1910. Research shows that many of the ladies of Rugby, young and old, were quite independent, often riding and driving alone.

Ernest V. Alexander arrived in Rugby in 1881 and was one of the few British younger sons who remained in Rugby his entire life. Early newspapers show him running a "spring dairy" and playing rugby football. He married Ina Giles in 1885 and built a home he named Sunnyside across the White Oak River and this swinging bridge to reach it. Here Ina is crossing the bridge in 1911.

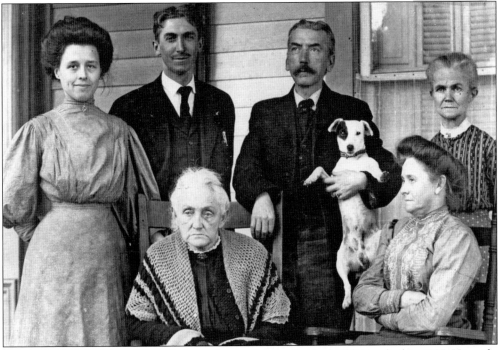

Beriah Riddell, builder of Twin Oaks and several other Rugby buildings, died in 1897. His wife, Mary, lived on there with her daughter and family, eventually becoming blind. The family posed for this picture around 1907. Seated in front are Mary Riddell (left) and Elizabeth Hadden Coakley. In back from left to right are Dannie Hadden, Clifford Hadden, Francis J. Coakley, and Matilda Hopper, their housekeeper, who was said to have contact with the supernatural.

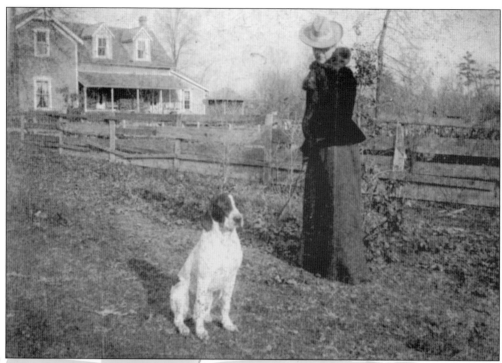

An unidentified lady is walking her dog around 1910. The home in the background was built in the 1880s and was known as both Roadside Cottage and Grey Gables.

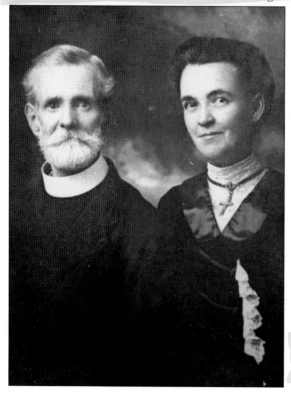

Rev. Benjamin T. Bensted and his wife, Jessica, lived in Grey Gables from 1912 to 1925. He served as vicar of Christ Church and was much beloved by the community.

Nellie Schenck's family lived in Allardt when Rugby was first established. She became a naturopathic doctor and midwife. Dr. Schenck delivered many babies in Rugby in the early 1900s. This picture of her is dated 1913.

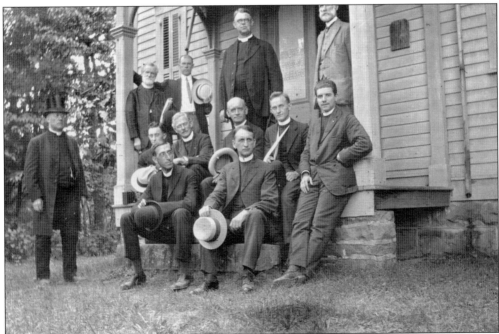

Rev. Benjamin Bensted is shown at the Hughes Library, leaning against the porch post at left. Charles C. Brooks is next to him. The group of priests was apparently visiting from other parishes.

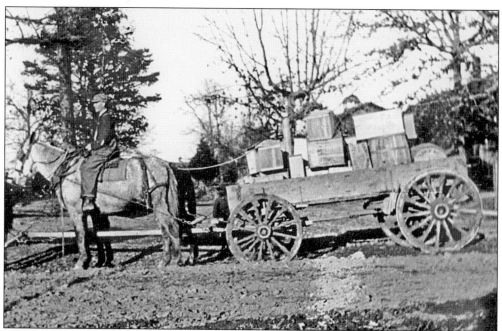

Gilbert Brooks, from up the road in Armathwaite, is shown hauling a load of freight through Rugby in 1913 from the Cincinnati Southern Railway station at Rugby Road, formerly Sedgemoor.

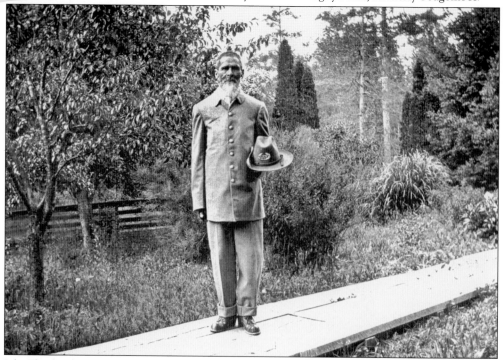

Jake Fletcher brought his family across the mountains from West Virginia on foot and by horseback and settled across the river in Fentress County. He worked in Rugby on construction projects and joined the Rugby Masonic Lodge. He posed for this picture in front of Walton Court in the early 1900s in what appears to be a Civil War uniform.

Two of Jake Fletcher's daughters made permanent homes in Rugby, and both were unique additions to the community. Laodicea, or Aunt Dicie as she came to be known, is shown here in her later years still weaving intricate coverlets right up to her death in the 1920s. Her sister, Lizzie, who was said to know dozens of old British ballads, is not pictured in this volume.

Children continued to enjoy Rugby life, as shown in this early-1900s picture of, from left to right, Brady Goad, Lawrence Young, and Harry Young.

The two children playing in front of the Alexander/Perrigo boardinghouse around 1913 are Harold Stockton (left) and his unidentified cousin. Which house is visible on the right is uncertain.

Edwina Hammond plays in the corn patch around her family's home in 1915. The building in the background held a grinding mill, which backed up to Reading Road for easy wagon access. The family lived in the house built by Cornelius Onderdonk.

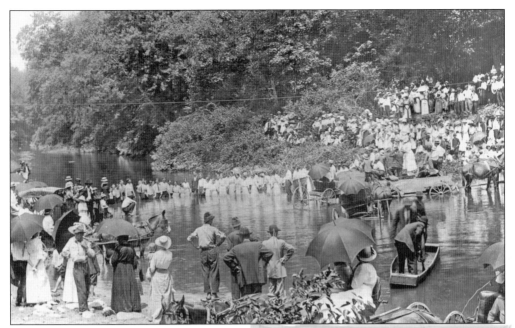

Notes from a Fentress County history say that 72 people were baptized the day of this picture in 1914. The location is on the Clear Fork River just below the Rugby town site. Rev. Melvin Russell performed the ceremony. Those baptized include members of the Hull, Voiles, Range, and Tompkins families. Cordell Hull, whose uncle once ran a blacksmith shop in Rugby, is one of the names listed.

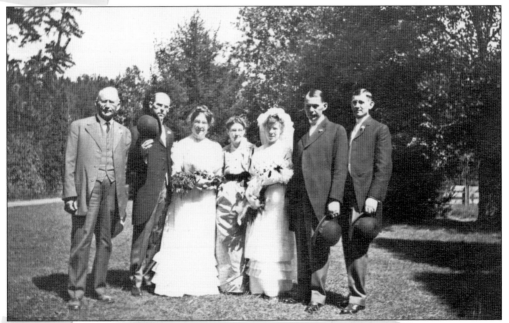

Edith Walton married Walter Hunt Tally on September 16, 1914, at Christ Church. This wedding picture was taken on the Walton Court lawn. The groom and bride are second and third from the right. Next to Edith are her mother and her sister, Esther, who had married Willard Keen of nearby Huntsville (on right) in 1908.

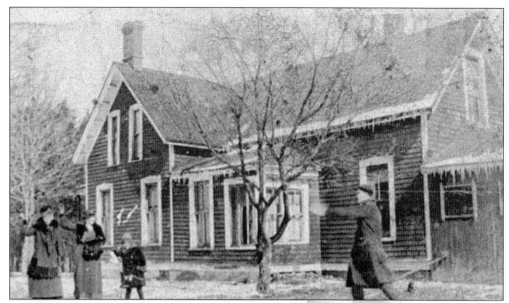

The home built for Daniel Ellerby in the 1880s appears in this 1918 picture dripping with icicles. Eland Hammond (right) is throwing snowballs at, from left to right, Margaret Tompkins, Charlotte Morton, and little Gladys Voiles. The home was later bought by Irving and Ida Mae Martin and named Ruralia.

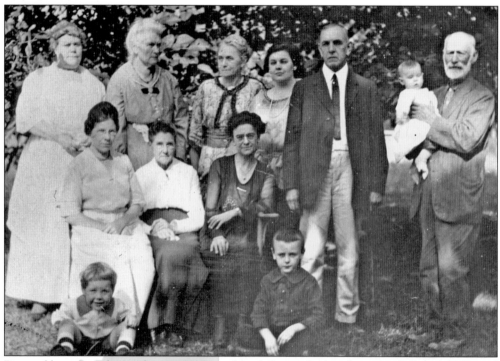

Pictured here near the Lindens in 1921 are, from left to right (on the ground) Robert Tally and Dunning Summers; (seated) Edith Walton, Elizabeth Walton, and Etta Dunning; (standing) unidentified, Ida Mae Kellogg, Elizabeth Coakley, Leslie Dunning and her husband, and Nelson Kellogg holding Anna Joyce Walton, Will and Sarah Walton's baby daughter.

The whole community loved George and Annie Berry, the English couple who lived in Rugby from the 1880s until their deaths in the 1920s. Their daughter, Bessie, shown standing, stayed with them until they died, then became a nun. The grounds of the Berry home, Idylwild, were filled with blooming flowers from spring to fall.

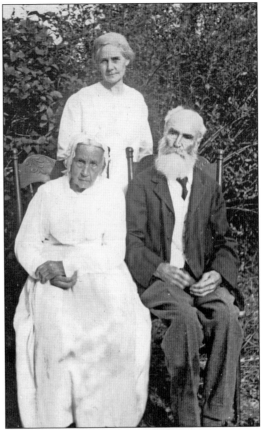

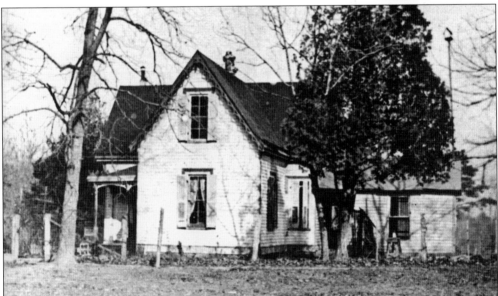

Though Cornelius Onderdonk built some of Rugby's most substantial buildings, he built himself this quite modest cottage in 1881. The house is pictured around 1918, when the Hammond family lived there.

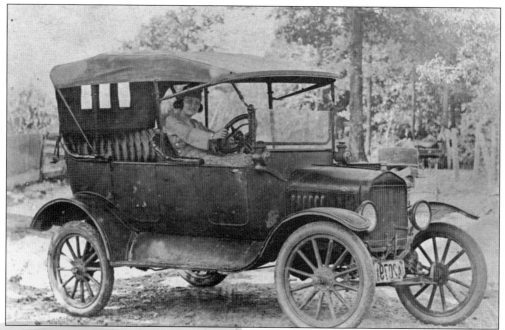

Will Walton bought his first car around 1919. Neighbor Lola McKay is at the wheel.

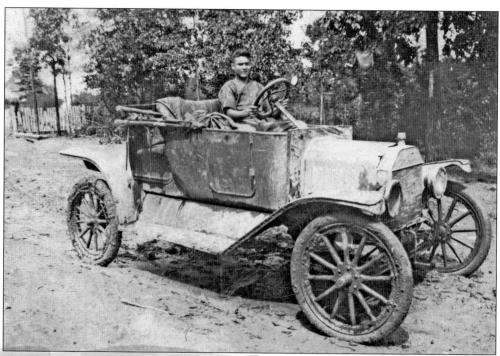

Eland Hammond also bought his first car in 1919 and wrote details on the back of this picture: "Purchased from M. H. Davidson for $50, winter 1919 by Eland Hammond, my first car, 1913 Ford roadster." Eland's friend, Virden Voiles, is in the car.

Samuel G. Wilson was another younger son from England who remained in Rugby his entire life. Rugby's children affectionately called him "Uncle Sam." He served the village as postmaster and as lay reader at Christ Church for many years until his death in 1936. He once told a magazine writer that his secret to happiness was never shaving and never marrying. He stands in front of his home, Virgo House, in this 1920s photograph.

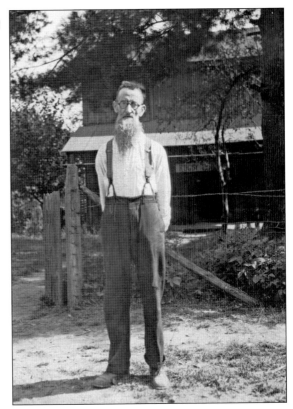

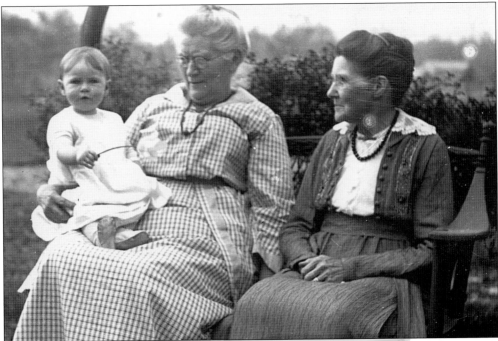

Two proud grandmothers visit with young Anna Joyce Walton, born in 1920. Ida Mae Kellogg is holding the baby; Elizabeth Walton is at right.

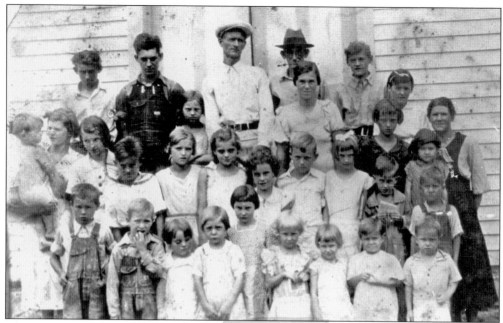

A group of Rugby schoolchildren pose for this 1920s picture. A young Joe Gibson, who was a mainstay of the Rugby community into the 1990s, is the first person on the left in the top row.

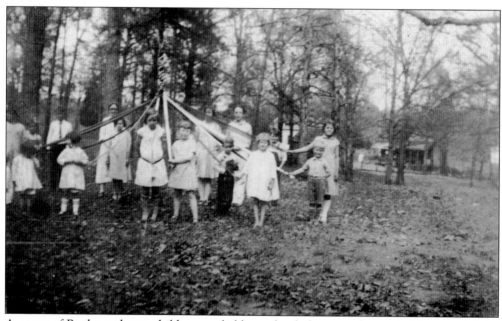

A group of Rugby and area children, probably a school class, are shown dancing around the maypole in 1928.

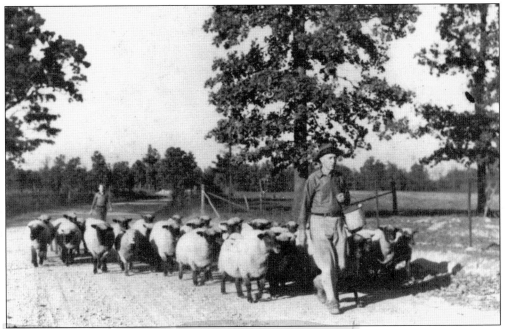

Charles C. Brooks, who married Nellie Lender Oberheu in 1902, is pictured with his herd of sheep around 1930. He and Nellie bought Uffington House from Emily Hughes shortly after their marriage and remained there the rest of their lives. Nellie turned the house into a veritable museum of early Rugby materials. Brooks became Rugby's most successful farmer and served as Morgan County's first farm agent.

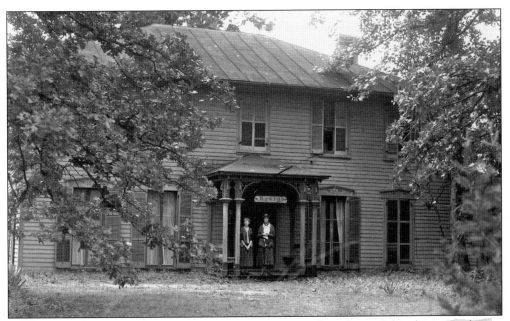

Helen Turner (right) is pictured with her aunt, Caroline Hill, in front of their home, Roslyn, in the 1930s. Her father, Judge Charles Turner, was dean of the College of Law at the University of Tennessee and purchased Roslyn for summer getaways.

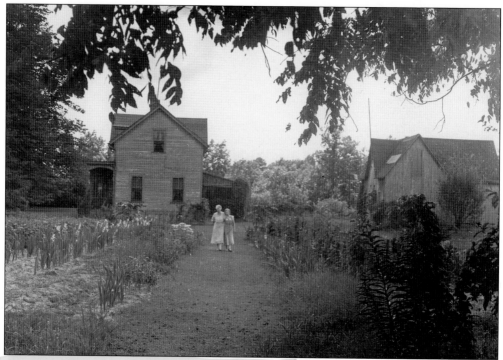

A teenaged Anna Joyce Walton strolls with her mother, Sarah, on the grounds of the Lindens. Sarah was known for her beautiful gardens. The original carriage house is on the right.

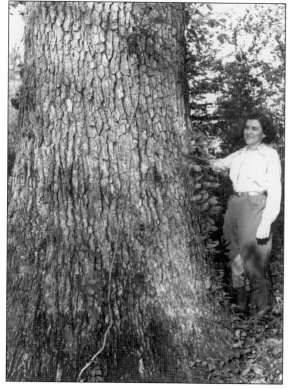

This picture of Virginia Keen, Esther Walton Keen's daughter, was taken in the 1930s for a Chattanooga newspaper article about the threat to Rugby's old trees. A lumberman had obtained extensive timber rights and begun cutting. Community members, led by Will and Sarah Walton, appealed all the way to Gov. Prentice Cooper and even to Pres. Franklin Roosevelt, but only the trees directly inside the village were saved.

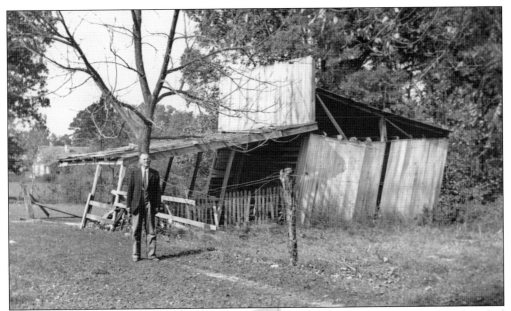

While living in Rugby, the Hammond family ran a store to the west of their home. This unidentified man is looking at what was left of it in the 1930s or 1940s.

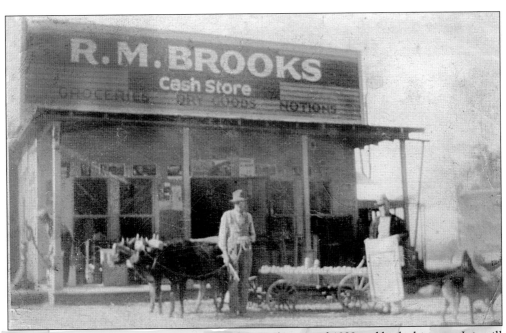

Robert Monroe Brooks and his family moved to Rugby around 1929 and built this store. It is still operated today by his granddaughter, Linda Brooks Jones, and her husband, Bill Jones. Uncle Jimmy Berry is on the left and Robert Brooks on the right in this early photograph. (Courtesy Linda Brooks Jones.)

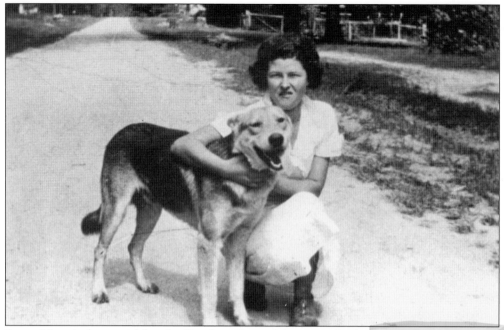

Emma Myers is shown with her dog Dutch on Central Avenue in Rugby not long before it became a blacktop road in the late 1930s. Myers's father was in charge of building the new road to and through Rugby. Everyone involved with the project lived on the Brookses' Uffington House property in tents set up on wood floors.

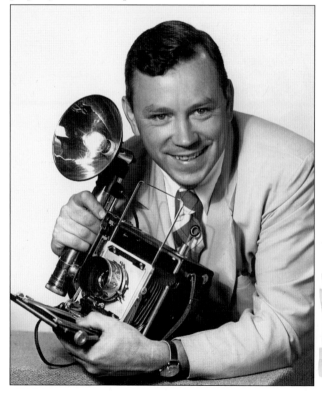

Esther Walton Keen's son, James, became a successful newspaper photographer and the person most responsible for saving many historic Rugby pictures. He also took many photographs of life in Rugby from the 1930s to the 1970s. He donated all his works to the Rugby Archives.

The baluster from England's Tabard Inn that was displayed at Rugby's Tabard Inn was saved both times the inn burned. James Keen photographed Will Walton displaying the artifact for a Rugby article that appeared in *Holiday* magazine in 1948.

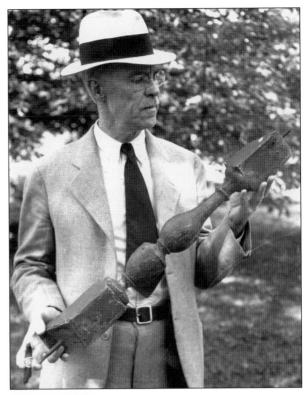

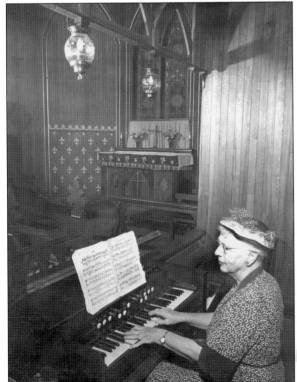

This picture of Sarah Walton playing the 1849 harmonium reed organ in Christ Church also appeared in the *Holiday* magazine article. Sarah was the church organist for nearly four decades.

James Keen's wife, Ruth (left), and Virginia Keen Zepp show off some of the vintage clothes of early Rugby's ladies.

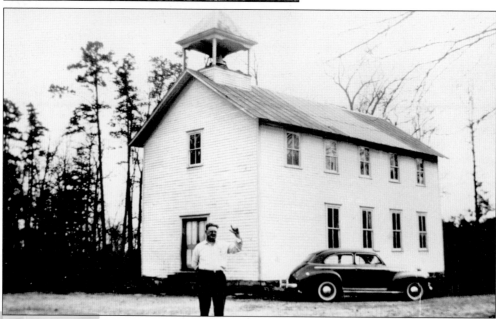

Eland Hammond never forgot his early years in Rugby. He would come over from Jamestown regularly to "check on the old place" and talk to friends. Hammond stands, about 1940, in front of the 1906 Rugby School he attended. When the earlier school burned, this one was immediately built on the same foundation. Classes were held here until 1951. Nellie Oberheu Brooks's daughter-in-law, Marcella, was the last person to teach there.

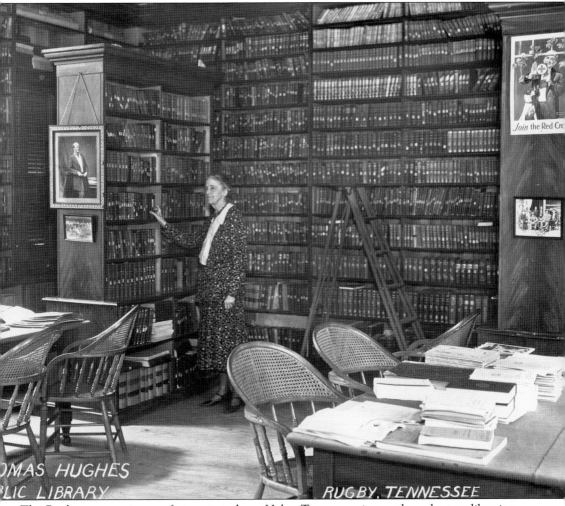

OMAS HUGHES
LIC LIBRARY RUGBY, TENNESSEE

The Rugby community was fortunate to have Helen Turner serving as the volunteer librarian at the Thomas Hughes Library for many decades. Schoolchildren from next door were her most frequent patrons. She worked as a librarian at the University of Tennessee's law library until her retirement.

This photograph of Samuel Wilson's home, Virgo House, was taken in the 1940s, several years after he died. The big white pine shading it was a Rugby landmark no longer standing today.

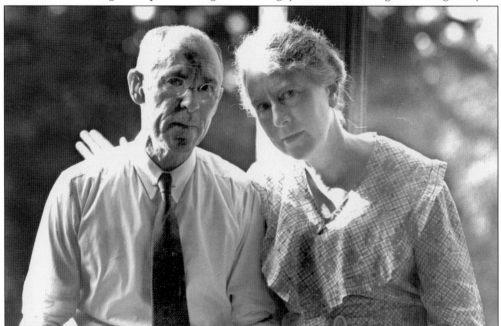

Will and Sarah Walton's nephew, James Keen, took this candid picture of the couple in the 1940s. Many people called them "the keepers of Rugby" for their tireless community work and care of historic buildings and materials. Visitors from the 1920s through the 1950s would often happen upon either Will or Sarah and receive an impromptu tour of the library and church.

Sarah Walton checks her weather station in this 1940s photograph. According to her daughter, Anna Joyce Walton Herr, a government agency provided the weather monitoring equipment, and Sarah made regular reports on Rugby's weather for many years to officials in Cookeville, Tennessee.

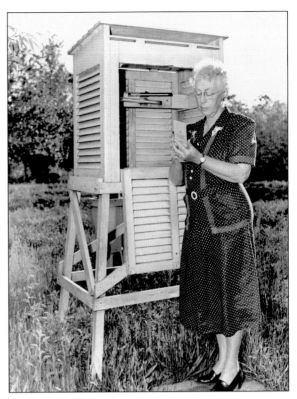

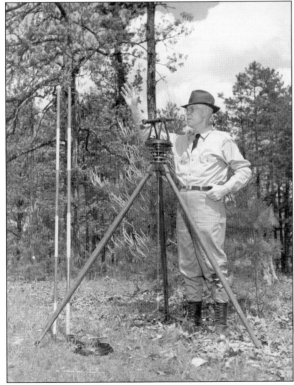

Like his father, Will became an expert surveyor. He is shown in 1946 using his father's surveying equipment. Many of Walton's skillfully drawn survey plats and maps are in the Rugby Archives.

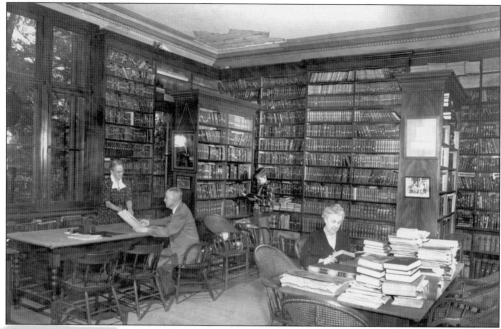

The Hughes Library was treasured and used by Rugby's aging residents as well as the schoolchildren. Nona Smith (left) shows Willard Keen a book while Esther Walton Keen reads at the other table and Robert Crabtree searches the shelves. Water seepage in the ceiling is starting to damage the plaster.

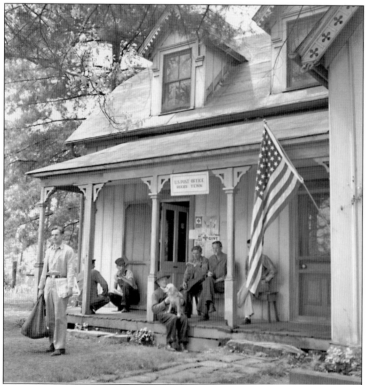

During the 1940s, Thomas Hughes's home, Kingstone Lisle, served as the village post office, run by sisters Nona and Lola Smith. Villagers lounge on the veranda as a postal worker leaves with the daily mail in this 1948 picture.

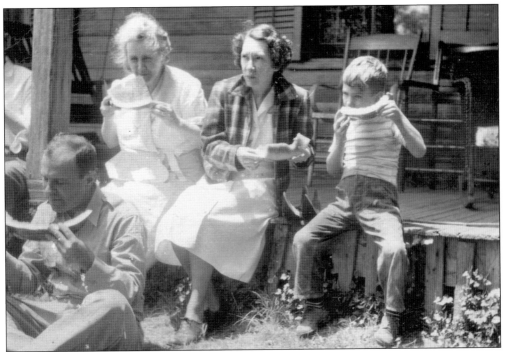

Walton Court remained a family gathering place. Family members are enjoying watermelon on a pleasant summer afternoon in 1948. From left to right are Randall Zepp, Flora Keen, Elizabeth Keen Crabtree, and Robert Crabtree.

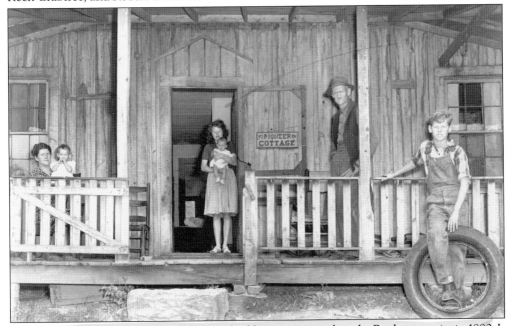

Pioneer Cottage was literally the first frame building constructed on the Rugby town site in 1880. It was briefly called the Asylum, as many young Englishmen found temporary lodging there. Several different families lived in Pioneer through the years. This photograph of the Bertram family was taken in 1948. The original sign, made in 1883 by George Berry, is still on the porch wall.

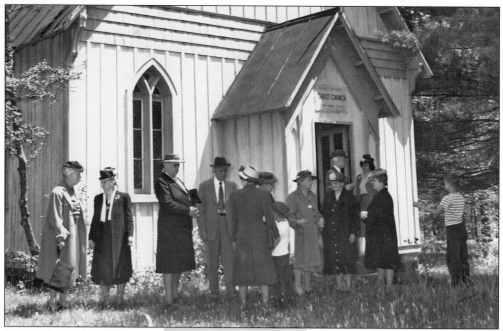

Part of the congregation visits in front of Christ Church after attending services. From left to right are Sarah Walton, Esther Keen, Anna Cebrat, Willard Keen, two unidentified, Robert Crabtree, Nellie Brooks, Helen Turner, unidentified, Will Walton on steps, Virginia Keen Zepp next to Walton, and on the far right, Charles Crabtree.

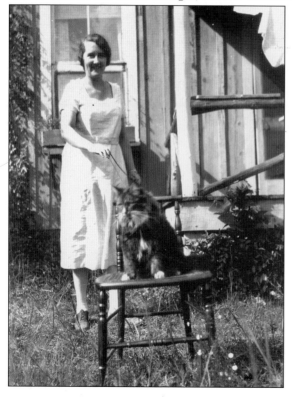

James and Jennie Lourie's daughter, Helen, retired to Rugby after working for the Stearns Coal and Lumber Company in Kentucky. Everyone knew Helen Lourie loved cats and often brought her strays. The cat shown here was surely the largest in Rugby.

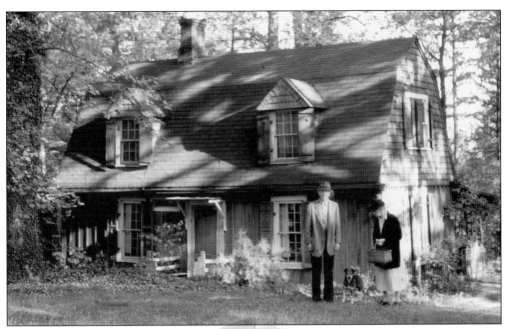

James and Jennie Lourie are shown in the early 1950s strolling over to Wren's Nest, the quaint cottage built by the Wellmans in the 1880s behind Adena Cottage. Mr. Wellman first used it to house a manager for a poultry operation he was starting. Later an Episcopal church worker, Lucy Archer, lived in Wren's Nest while serving the Rugby community.

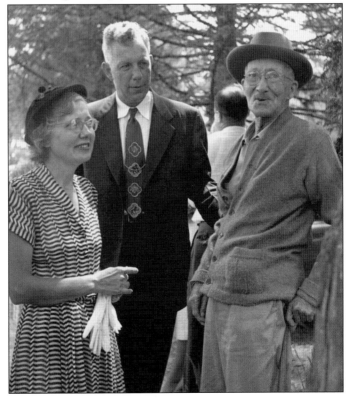

Ernest Alexander (right) was much written about and photographed over the years as the oldest surviving Rugby colonist and a successful farmer. He emigrated from England in 1881, lived in Rugby until his death in 1956, and is buried in Laurel Dale Cemetery. Here he visits with C. L. Crabtree and Marcella Brooks several years before his death.

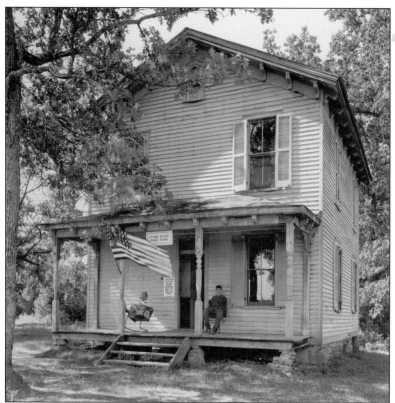

The Board of Aid also served as Rugby's post office after the Smith sisters died. Robert Crabtree, right, visits with the unidentified postmaster.

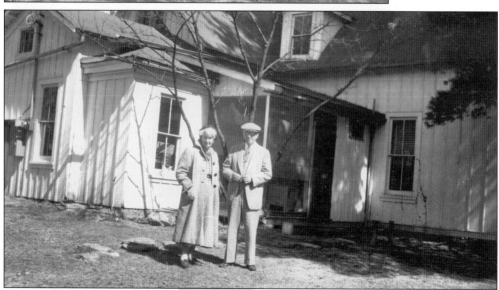

Patricia Guion Wichmann lived in Kingstone Lisle in the 1890s as a child. Her father taught the Rugby School. After years of government service, she realized her dream of returning to her childhood home when she and her husband, Hugo, retired to Kingstone Lisle in 1953. Patricia Wichmann researched and wrote booklets about Rugby's history and documented her detailed childhood memories in letters now in the Rugby Archives. The Wichmanns sold the home to the new Rugby Restoration Association, founded several years before their deaths.

The Tennessee Historical Commission put up this marker at the state highway crossroads east of Rugby in the 1950s. James Keen took this picture of his daughter Louise, at right, and his niece, Karen.

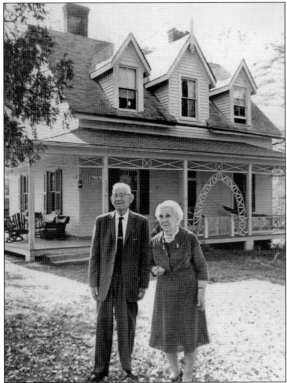

This is one of the last photographs taken of Willard and Esther Walton Keen at Esther's childhood home, Walton Court. Esther's memories of early Rugby, where she was brought at age two, remained strong until her death in 1968. She was constantly called on to identify old Rugby photographs, including many on these pages. In 1965, she was tape-recorded for hours by a teenage boy, Brian Stagg, who was beginning to lead the restoration of Rugby, Tennessee. Walton Court with its original furnishings was lost to fire in 1988. It was historically reconstructed in 2007 by Esther's grandson, George Zepp.

This 1965 photograph of the congregation at Christ Church Episcopal includes several descendants of the Walton and Keen families. Young Brian Stagg, who would become the first director of the Rugby Restoration Association, is the first person on the left in the third pew. His parents, Dorothy and Ted Stagg, are next to him. George Zepp is directly behind Brian.

Four

RESTORING THE DREAM

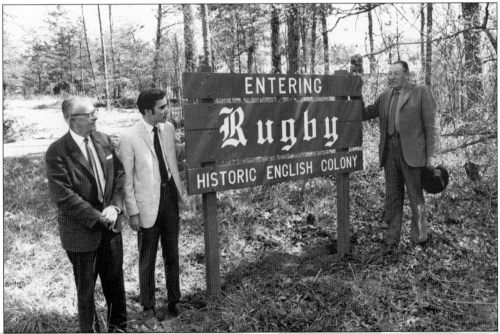

Entrance signs were placed on each end of the Rugby village in 1966, when the restoration effort officially began. From left to right, Stanley Warner, Brian Stagg, and Oscar Martin were photographed after helping install them. Warner was a founding board member and Martin served as the first president of the board. Work to incorporate a nonprofit organization that could accept tax-deductible donations began right away, followed by a membership drive. A few dozen of those who became members in 1966 are still active members today.

Restoration Of Rugby Is Goal Of New Organization

Officers and directors of the recently organized Rugby Restoration Association are highly encouraged with the results of the pilgrimage to Rugby last Sunday.

Highlight of the pilgrimage, sponsored by the organization chartered in June of this year, was the address by Dr. Sam Smith, Chairman of Tennessee Historical Association and State Historian. Dr. Smith, addressing a large group from the veranda of the lovely home of Mrs. Thula Justiss, "Roslyn", said Rugby was one of two towns in Tennessee being considered for restoration. Dr. Smith said he first visited Rugby in 1959 when he was doing research for a thesis on Joseph Buckner Killebrew. He said Col. Killebrew, as Commissioner of Mines, Agriculture and Statistics, recommended the townsite of Rugby to Thomas Hughes.

Mrs. Alice Warner Milton, president of the Fort Loudon by would be in the Historic Sites Program of the Historical Commission. "The Rugby Project," Mrs. Milton said, "will be the greatest restoration undertaken in Tennessee because the ideals and spirit were right."

Both Dr. Smith and Mrs. Milton spoke following a business meeting at which Brian Stagg of Oak Ridge and Deer Lodge, was named Executive Director of the Association. Stagg, a freshman at the University of the South, spearheaded the organization of the Deer Lodge Historical Association which is being merged with the Rugby organization. Stagg is also the author of a book on the History of Deer Lodge.

Oscar Martin of Rugby, as president of the association, presided over the meeting. Martin is a retired executive of the Portland Cement Company. Other officers are Mrs. Thula Justiss of Rugby, a retired public relations officer,

THE OFFICERS - The officers of the recently organized Rugby Restoration Association are: (l-r) Brian Stagg, executive director, Oscar Martin, president, Mrs. Thula Justiss and Mrs. Elizabeth Crabtree, vice-presidents and Miss Helen Lourie, secretary and treasurer.

This 1966 newspaper clipping reports the establishment of the Rugby Restoration Association (RRA) and election of officers and describes its first public pilgrimage. Pictured from left to right are (first row) Thula Justiss, vice president; Elizabeth Crabtree, vice president; and Helen Lourie, secretary and treasurer; (second row) Brian Stagg, executive director, and Oscar Martin, president.

Oscar Martin discovered Rugby when working to build a new paved highway through the village in the early 1940s. He immediately bought land and one of the old houses and started bringing his family to Rugby from their Gallatin home every summer for decades. He and his wife, Allen Palmer, dedicated themselves to Rugby's restoration and preservation and passed their love of the place to their children and grandchildren. Both are buried at Laurel Dale Cemetery.

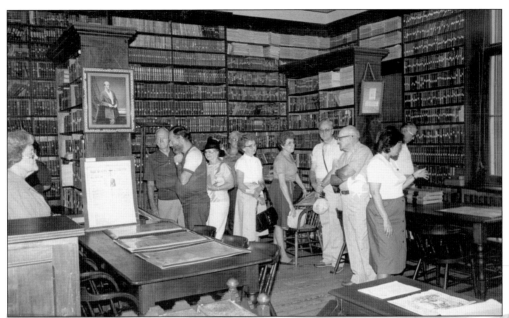

Soon after the restoration organization started, guided tours of Hughes Library, Kingstone Lisle, and Christ Church began. Here a group visits the library. Brian Stagg worked for several summers to relabel and reshelve any books that were out of order, using first librarian Edward Bertz's original handwritten catalog. The library needed little restoration—it had been lovingly cared for by aging residents for decades.

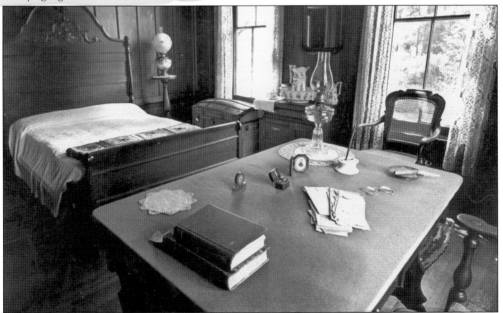

Restoration work to return Kingstone Lisle to its original appearance, inside and out, went on for several years. Wallboard removal revealed beautiful, heart-pine walls and wainscoting; a cold cellar was discovered under the back porch. A consultant was hired to help with a museum-quality furnishings plan. Bedroom furnishings include a writing table made in the colony for Thomas Hughes and a cherry bed from Twin Oaks. The washstand on the right came from the Tabard Inn.

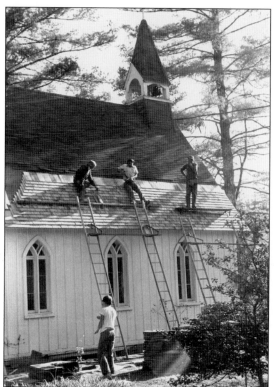

Restoration of Christ Church Episcopal by RRA in the 1970s included foundation and chimney stabilization, reroofing with sawn wood shingles as shown in early pictures, and painting the building in its original colors. A central heating system was also financed so year-round services could resume.

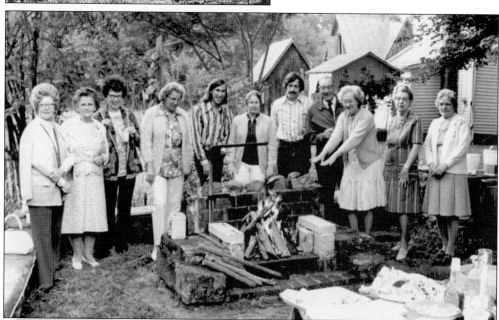

Restoration staff and community members found time to gather at the Lindens' outdoor fireplace for a potluck dinner in 1972. Pictured from left to right are ? Galloway, Thula Justiss, unidentified, Ruth Keen, Lonnie Berry, ? Marsh, Len Marsh, Oscar Martin, Helen Lourie, Allen Palmer Martin, and Dorothy Stagg. Around this time, Rugby was officially listed on the National Register of Historic Places as a historic district.

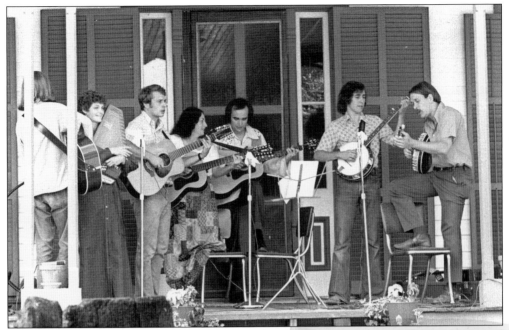

Music often rang out on the broad back veranda of historic Roslyn house in the 1960s and 1970s. Performing for a pilgrimage crowd are, from left to right, Paul Bonner (with back to camera), Sarah Bonner, Ted McNabb, George Anne Egerton, Brian Stagg, Michael Stagg, and an unidentified player.

Brian Stagg is upstairs at the Board of Aid office about 1974 going over plans with Mary Oehrlein, a historic paint consultant. The original 1880s drawing table where they are working, and several other pieces, had been in the building since it was the headquarters for incoming colonists during Rugby's early years.

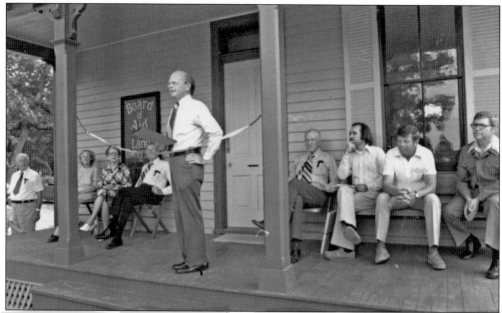

The restored Board of Aid to Land Ownership was formally reopened as headquarters for the RRA in the summer of 1976. Seated on the porch from left to right are Helen Lourie, Allen Palmer Martin, Oscar Martin, Irving Martin, Brian Stagg, Noel Martin, and Bill Goodwin. Len Morgan is speaking. Stagg died that October. Arsonists burned the Board of Aid building in July 1977, as well as a community craft cooperative and lending library next door in the old Stockton store.

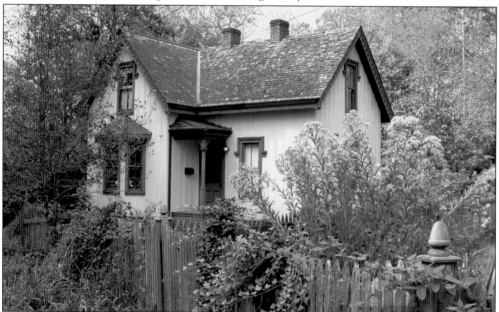

Percy Cottage, originally built by Henry Kimber and named for his son, had just been historically reconstructed and Barbara Stagg, Brian's sister, appointed as RRA executive director when the Board of Aid burned. Staff and board members quickly moved the few furnishings and records saved from the fire into Percy, and Rugby remained open to the public. Percy served as headquarters for 10 years.

Restoration began on the 1906 schoolhouse in the 1980s. The biggest challenge was ridding the building of 50 years of bat guano and its attendant odor. In 1987, the schoolhouse opened as Historic Rugby's main visitor center and headquarters. Around that time, the organization changed its name from Rugby Restoration Association to Historic Rugby.

A huge new neighbor emerged adjoining Rugby in the 1970s–1980s with the development of the 125,000-acre Big South Fork National River and Recreation Area. Historic Rugby worked with its planners from the beginning to assure that the park's impact on Rugby would be primarily positive. Thomas Hughes would be pleased to know that the beautiful streams and new trails he had set aside in 1880 are today part of the park and "free for the use and enjoyment of all."

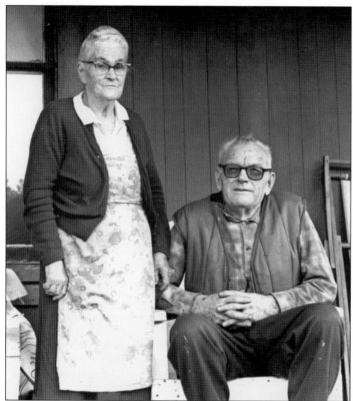

Lifetime Rugby residents Curtis and Nova Bertram were among many people interviewed during two different Tennessee Humanities Council grant projects in the 1980s that resulted in traveling exhibits. The research to better document Rugby history and its impact on surrounding communities resulted in more than 100 hours of oral history tapes and many historic photographs for the archives.

Historic Rugby convinced the U.S. Army Corps of Engineers, which was developing the new park, to fund a comprehensive master plan for Rugby's protection and controlled development. During the early-1980s planning process, many community meetings were held like this one in the Rugby Community Room. The resulting, national-award-winning plan is still used today to help guide Rugby's continuing preservation and controlled growth.

The centennial of Rugby's October 5, 1880, opening day was celebrated on October 5, 1980, with descendants of some of Rugby's key historic figures. Posing in front of Christ Church, where the ceremony took place, are Ivy Curzon from England, a longtime Hughes family researcher; writer John Egerton, whose English grandfather immigrated to Rugby; Hughes Martin, Oscar's grandson; Fr. Herman Anker, church vicar; David Hughes from Scotland, Thomas Hughes's great-nephew; and Sir Charles Kimber from England, Sir Henry Kimber's grandson.

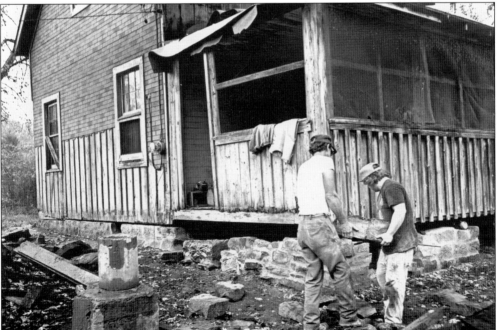

In 1981, Wayne (left) and Tracy Brewster work for the RRA to restore the colony's first frame house, Pioneer Cottage. Removal of layers of wallboard and paper inside revealed original wide, hand-planed poplar walls. Pioneer has been in use for visitor lodging since.

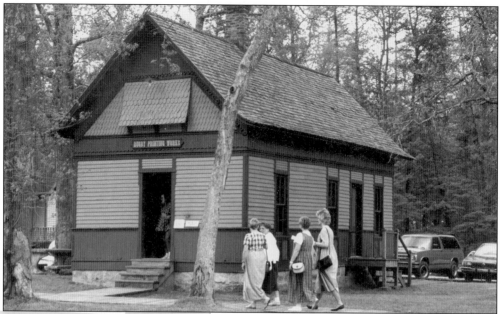

This print shop was built in nearby Deer Lodge in 1887. Deer Lodge was founded as a direct result of Rugby when Abner Ross, after running Rugby's Tabard Inn for several years, decided to start his own town. He financed building of a printing works in partnership with a Mr. Mason. Because of its historic connections, the building was moved to Rugby in the early 1980s, restored, and furnished as a working 19th-century printing business, just as Rugby once had.

Walter Clement, an expert in 19th-century printing technology, guided print shop restoration and donated many of the interior furnishings. He is shown here demonstrating a steam-operated peanut roaster at a 1990s event with some distraction by his dog, Tab.

Paul Blevins rode into Rugby on his motorcycle in the 1980s and decided to stay. He was first in line when Walter Clement began training volunteers to demonstrate hand-typesetting and foot-powered letterpress printing. Paul worked in the print shop for several years, and visitors loved to listen to his stories and observations.

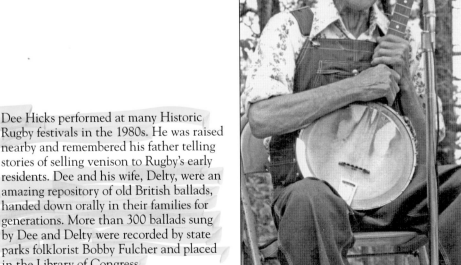

Dee Hicks performed at many Historic Rugby festivals in the 1980s. He was raised nearby and remembered his father telling stories of selling venison to Rugby's early residents. Dee and his wife, Delty, were an amazing repository of old British ballads, handed down orally in their families for generations. More than 300 ballads sung by Dee and Delty were recorded by state parks folklorist Bobby Fulcher and placed in the Library of Congress.

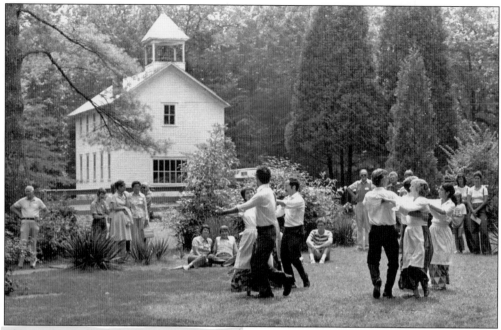

This Nashville English country dance group was the first to bring the delightful tradition to modern-day Rugby. They are dancing on the church lawn during a spring festival. The man at right in the white shirt with his back to the camera is Bob Hemminger, who now owns and has restored historic Wren's Nest in Rugby.

The story of Rugby's 19th-century founding and 20th-century restoration debuted on stage in 1985 at Crossville's Cumberland County Playhouse. Producing director Jim Crabtree spent many months on research before writing the script and lyrics, and Dennis Davenport wrote the music. It was produced again several years later at the University of the South. Because more than 8,000 people saw these productions, visitation to Historic Rugby more than doubled afterward.

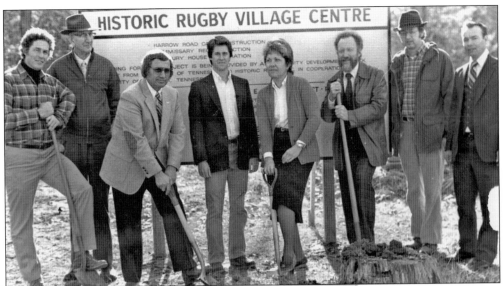

Historic Rugby added three new and restored visitor facilities in 1985. A state Community Development Block Grant was used to restore the 1880 Newbury House for visitor lodging, build a new, architecturally compatible restaurant, and historically reconstruct the Rugby Commissary for a museum and craft store. At the ground-breaking, from left to right, are Historic Rugby properties director John Gilliat, Virgil Easley, Allardt mayor Turk Baz, an unidentified contractor foreman, executive director Barbara Stagg, project architect Eugene Burr, board member Robert Lantz, and an unidentified contractor.

Historic Rugby board president and Walton descendant George Zepp visits with Brian and Barbara Stagg's mother, Dorothy, at a 1990 Rugby descendant reunion. She played many roles in Rugby for 25 years, running an early restaurant for residents and visitors, playing the organ weekly for Christ Church services, and serving as church secretary and treasurer. Zepp assisted in copying dozens of historic photographs for the Rugby Archives at the reunion.

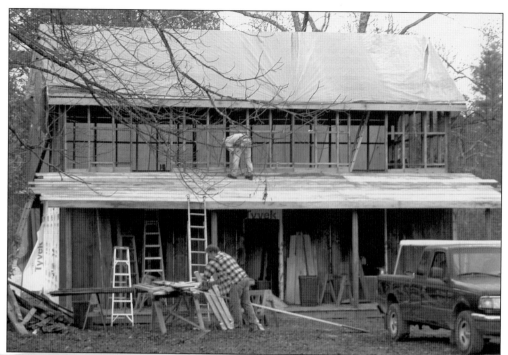

Restoration and reconstruction of 1881 Virgo House was a major project in 2005–2006. In the early months of restoration, John Gilliat saws lumber to hand up to Gerald Hanwright on the roof.

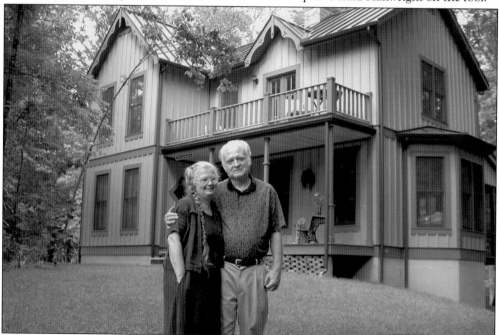

Lavonne and Charles Gibbs stand before their Beacon Hill home in 2005. Rugby began attracting modern-day colonists in the 1990s with the development of Beacon Hill, an area designated for residential development on Rugby's 1880 town plan. Homes built here must be architecturally compatible, based on the Rugby Master Plan's design guidelines.

Five

RUGBY TODAY

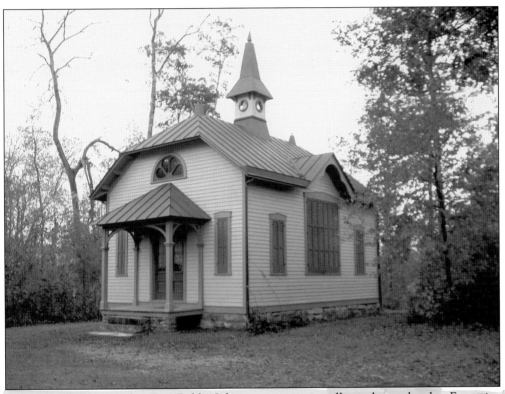

The 1882 Thomas Hughes Free Public Library remains virtually unchanged today. Extensive research indicates that it is the oldest free public library existing in America with its entire original collection, furnishings, and early checkout records still intact. The library is painted its original colors of three shades of grey, as documented by professional paint research. Film to block ultraviolet rays, which can fade the books, has been applied to all the windows. Historic Rugby is working to achieve a complete digital shelf listing of the 7,000-volume collection to aid research, which is currently allowed by prior appointment. Except for Christmas Day, New Year's Day, and winter weather days, the Thomas Hughes Library is open daily year-round on tour.

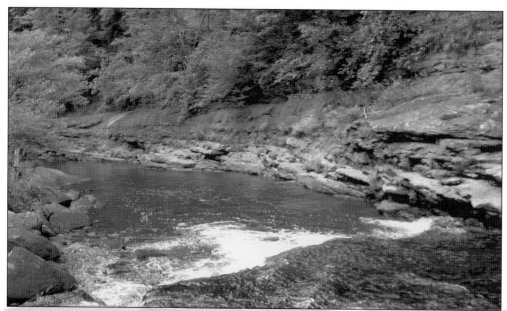

The rivers that surround the Rugby town site are still free flowing and are now contained within the Big South Fork National River and Recreation Area. The White Oak River, shown here, may be a bit smaller than the Clear Fork, but it is no less beautiful. Rugby residents and visitors still enjoy the pleasures of both, as the early Rugbeians did.

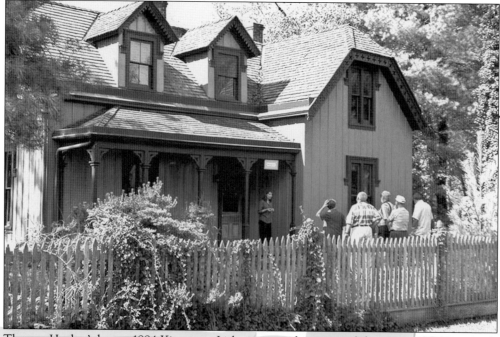

Thomas Hughes's home, 1884 Kingstone Lisle, is painted its original documented colors of rich tan with dark brown trim and deep maroon sashes and is surrounded by a replica picket fence. The gate has an original "Tom Donkey–proof" latch. The grounds are filled with heirloom plants. English primroses and Michaelmas daisies planted by early colonists have survived and still thrive here. Kingstone Lisle is shown daily on tour.

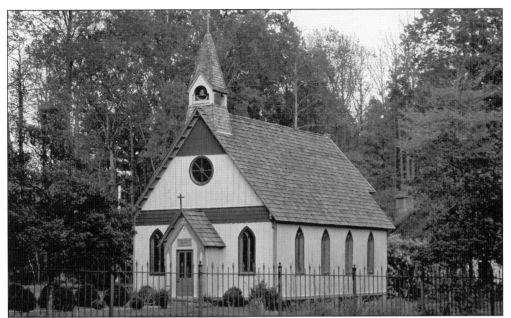

Christ Church's 1880s colors were quite a surprise. Paint research in the 1970s revealed peachy tan siding with grey and maroon trim. The church is owned by the Episcopal Diocese of East Tennessee, which allows it to be shown daily to visitors on tour. Services are still held every Sunday at 11:00 a.m. Eastern Time. The congregation continues to grow as new "colonists" make their homes in Rugby.

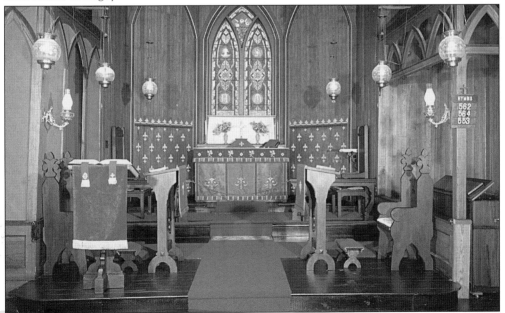

The interior of 1887 Christ Church is much as it was in its earliest years. Original hanging and wall oil lamps have been electrified, and the kneeling pad at the altar rail was replicated when the original became too frayed to use. Modern hymnals and Books of Common Prayer are used today, but some of the historic volumes are kept in a display case. The original walnut alms basins are still passed each Sunday for offerings.

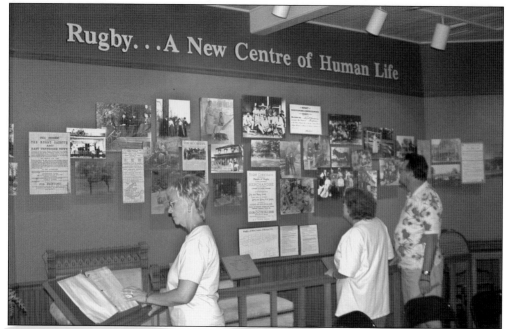

After restoration, the 1906 Rugby Schoolhouse served as Historic Rugby's visitor center until 2006, when a new facility was opened for that purpose. The schoolhouse remains open to daily visitors, with administrative offices upstairs. Visitors enjoy looking at the exhibits, which display some of the historic images in this book.

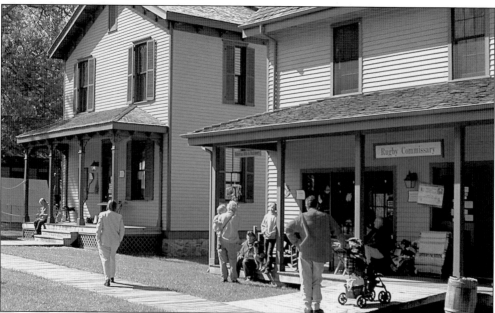

Both the Board of Aid to Land Ownership (left) and Rugby Commissary have been historically reconstructed on their original foundation sites by Historic Rugby. The Rugby Archive and Research Centre is upstairs at the Board of Aid; downstairs is an art and antique shop. The Commissary is now a museum store and craft center. It carries works of more than 100 area artisans, Rugby history items, and Victorian-era wares.

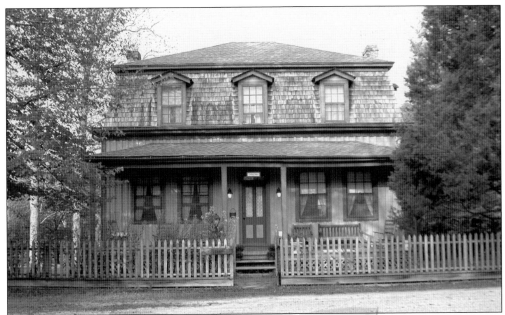

Of Newbury's several proprietors, the Kelloggs lived the longest there. After their deaths, their daughter, Sarah Walton, kept ownership until her death in 1959, when it was sold. Oscar Martin's son, Tom, eventually purchased it and allowed various Historic Rugby staff and consultants use of the house. Historic Rugby bought and restored Newbury in 1985; furnished it with period pieces, including some original to Rugby; and again opened it for year-round overnight lodging.

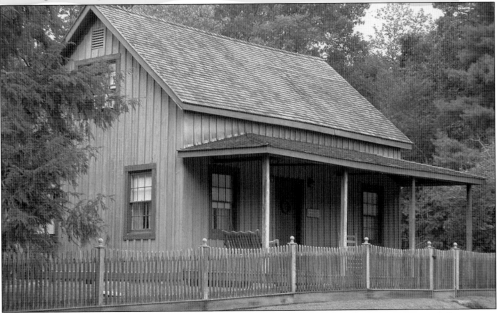

A history pamphlet for Pioneer's lodgers shares a quote from a letter Hughes wrote while staying here in 1880: "I sit writing in the verandah. Above, the vault is blue beyond description, studded with stars . . . the katydids are making delightful music. I shall turn in, leaving the windows wide open for the divine breeze to enter, wishing sleep as sound as they have so well earned to my crowded neighbours in this enchanted solitude."

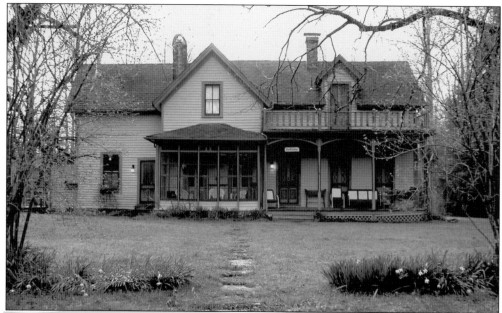

After Will and Sarah Walton's deaths, several Walton family descendants owned the Lindens. Each carried out stabilization and restoration work. The interior of the original carriage house in back has been turned into a guesthouse. Twin European linden trees planted by Nathan Tucker in front in 1885 (not visible in picture) are two of the largest of this species in Tennessee. The Michael Stagg family now owns the Lindens.

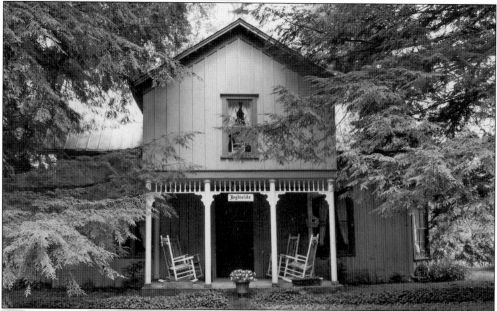

Ingleside is another of Rugby's surviving buildings. It was built in 1884 by Russell Sturgis, a successful Boston businessman and stockholder in the Board of Aid. Sturgis was the first American consul to Canton, China. Ingleside was once filled with art objects from travels with his wife in the Orient. Ingleside has seen several owners and uses over the decades. Today it is owned and cared for by James and Polly Allen.

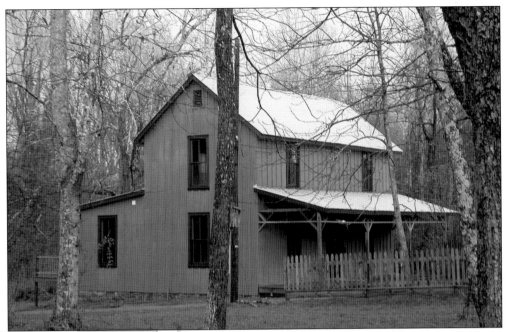

Uncle Sam Wilson's Virgo House, after restoration and reconstruction by Historic Rugby, looks much as it did when built in 1881. It is painted the same rich tan and dark brown documented on other early Rugby buildings. Virgo has been sold, with preservation easements attached, to a British couple, Bob and Jenny Young.

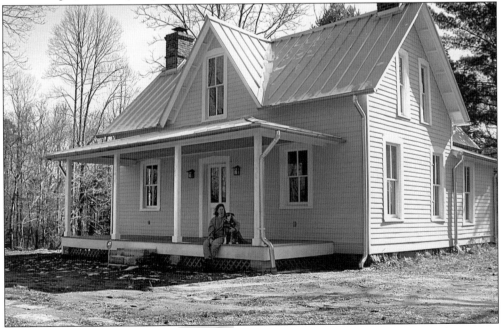

Several additions were made to Ruralia over the years, but fortunately the original structure remained intact. Historic Rugby was able to purchase it in 2004 and resell it, requiring the new owner to remove non-original portions and restore its original appearance. Restoration is nearing completion by owner Marlee Mitchell, shown on the front porch with her dog, Mac.

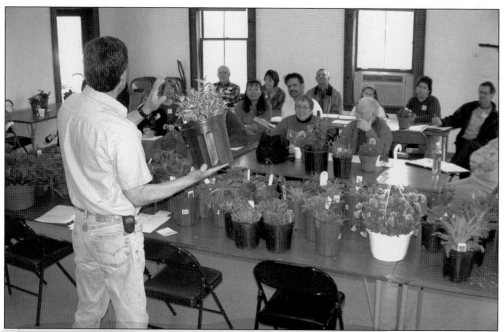

Historic Rugby sponsors a series of crafts and outdoor workshops every year. Classes vary and can include white oak and honeysuckle basket making, quilting, dulcimer playing, and woodcarving, as well as outdoor activities such as wildflower walks, bird watching, and Victorian gardening, pictured here with Bob Washburn instructing.

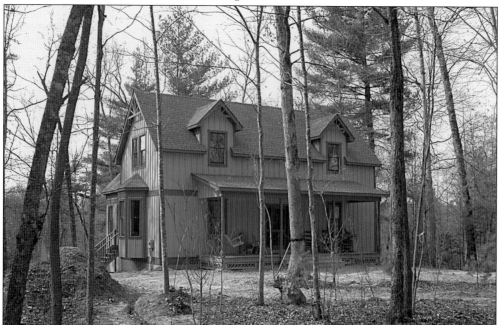

All 32 lots in Beacon Hill have been sold, 18 architecturally compatible homes have been completed to date, and more are under construction. This cottage was built for former owner Sarah Senft and is now owned by Boyd and Barbara Mitchell. Several more lots, as planned in the 1880s, will be developed in other areas of Rugby.

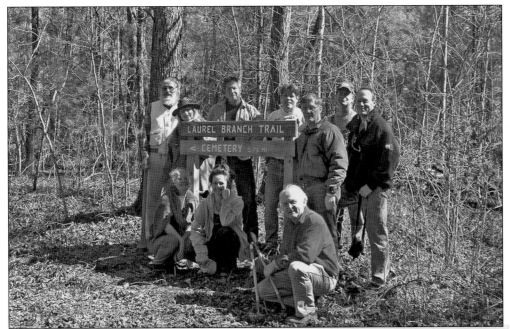

Just as in the 1880s, Rugby residents and friends get together to maintain the historic trails still open throughout the town site and occasionally to develop new trails. Shown in 2004, from left to right, are (first row) Lavonne Gibbs, Lesa LeMarr, and Charles Gibbs; (second row) Eric Wilson, Vi Biehl, John Gilliat, Gerald Hanwright, Julian Bankston, Ron LeMarr, and Chris Gibbs.

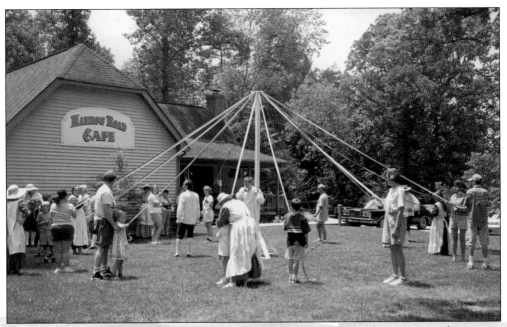

Residents and visitors still dance around the maypole every year at Rugby, as seen in this picture taken during a recent Festival of British and Appalachian Culture. Lark in the Morn English Country Dancers lead the dance.

Memberships and donations from hundreds of people over many decades have helped make the restoration and preservation of Rugby possible. Among those at a 2004 Thomas Hughes Society dinner honoring major donors are, from left to right, Historic Rugby development director Joe Beavon, Harry Hester, JoNell Hester, and executive director Barbara Stagg.

Descendants of early colonists and others involved with Rugby's past often donate items with historic connections to Historic Rugby. Shown with the 1904 horse-drawn road grader they donated in 2006 are, from left to right, Arthur Taubert, Jim Lawhorn, Cheryl Walker Copeland, and Hazel Tompkins Walker. The grader was used to maintain Rugby-area roads.

More than 200 residents, descendants, and others gathered near the foundation of the Tabard Inn on October 5, 2005, to re-create and celebrate the 125th anniversary of the founding of Rugby. The well-documented opening-day ceremony, including Thomas Hughes's own speech, was reenacted. Both participants and audience wore Victorian costumes, as this group picture shows.

Historic Rugby completed a new visitor center and theater in 2006 with funds raised from its ongoing Legacy Campaign. A 32-foot wall mural inside shows the Rugby colony as it appeared in the 1880s. The 110-seat Rebecca Jones Johnson Theatre is named for one of Rugby's early schoolteachers. Historic interpreter Sandra Moss (front) is starting a building tour with an Elderhostel group.

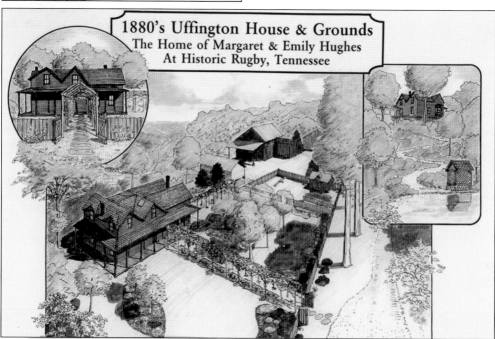

1880's Uffington House & Grounds
The Home of Margaret & Emily Hughes
At Historic Rugby, Tennessee

Another Legacy goal is the complete restoration and public opening of Uffington House and grounds, where Margaret and Emily Hughes and later Charles and Nellie Lender Brooks lived. Information from hundreds of family letters and pictures, many taken by Emily Hughes, will help transport visitors to early Rugby as they tour the house and grounds. Brooks's 1930s potato house will house an entry exhibit. Work is ongoing at Uffington House as the Rugby story continues.

BIBLIOGRAPHY

Board of Aid/Historic Rugby. *The Rugby Handbook.* Facsimile edition. Rugby, TN: Historic Rugby Press, 1996.*

Brooks, Nellie Lender. *Sketches of Rugby.* Rugby, TN: Self-published, 1941.*

DeBruyn, John. *A New Centre of Human Life: The Family of Thomas Hughes At Rugby, Tennessee.* Rugby, TN: Historic Rugby Press, 1996.*

Egerton, John. *Visions of Utopia.* Knoxville, TN: University of Tennessee Press, 1977.*

Hamer, Marguerite. *Cameos of the South: Thomas Hughes and His American Rugby.* Philadelphia, PA: John C. Winston Company, 1940.

Historic Rugby. www.historicrugby.org

Hughes, Emily. *Dissipations at Uffington House: The Letters of Emily Hughes, Rugby, Tennessee, 1881–1887.* Edited by John R. DeBruyn. Memphis, TN: Memphis University Press, 1977.

Hughes, Thomas. *Rugby, Tennessee: Being Some Account of the Settlement Founded On the Cumberland Plateau.* London: Macmillan and Company, 1881.*

Mack, Edward and W. H. G. Armytage. *Thomas Hughes: The Life of the Author of Tom Brown's Schooldays.* London: Ernest Benn Limited, 1952.

Stagg, Brian. *The Distant Eden: Tennessee's Rugby Colony.* Rugby, TN: Paylor Publications, 1973.

Tennessee State Library and Archives. *Rugby Papers.* Nashville, TN. 1872–1942. MS Div. Ar. Nos. 145, 1661, 1740, 67–89, 68–81; Microfilm accession nos. 39, 239, and 253.

Walton, Esther. *The Hermit, the Donkey and Uncle Dempsey: Recollections of a Rugby Girl.* Edited by George Zepp. Rugby, TN: Historic Rugby Press, 1997.*

Worth, George. *Thomas Hughes.* Boston: Twayne Publishers, 1984.

* Available for purchase at Historic Rugby.

www.arcadiapublishing.com

Discover books about the town where you grew up, the cities where your friends and families live, the town where your parents met, or even that retirement spot you've been dreaming about. Our Web site provides history lovers with exclusive deals, advanced notification about new titles, e-mail alerts of author events, and much more.

Find Your Place in History.